D1452262

IMAGES
of America

CANNON BEACH

IMAGES
of America

CANNON BEACH

Deborah Cuyle

ARCADIA
PUBLISHING

Published by Arcadia Publishing
Charleston, South Carolina

Printed in the United States of America

Library of Congress Control Number: 2015936990

For all general information, please contact Arcadia Publishing:
Telephone 843-853-2070
Fax 843-853-0044
E-mail sales@arcadiapublishing.com
For customer service and orders:
Toll-Free 1-888-313-2665

Visit us on the Internet at www.arcadiapublishing.com

To my son Dane, who is possibly the only person in the world who might love Cannon Beach more than I do, and to all of the lifelong friends we made when living there. Every time I think of Cannon Beach I think of my favorite quote: "Friends are like seashells we collect along the way." We collected some great memories and some great friends there!

CONTENTS

Acknowledgments 6

Introduction 7

1. The Cannons and the Coastline 9

2. The Beach Draws the Businesses 17

3. Arch Cape, Hug Point, and Making the Roads 57

4. Ecola State Park and "Terrible Tilly" 83

5. From the Archives 101

ACKNOWLEDGMENTS

We would like to acknowledge all history lovers in this world who do what they can to preserve and protect our past. A big thank-you to Thomas Robinson and Norm Gholston; without their amazing photograph and postcard collections, this book would not be possible.

Thomas Robinson provides images to historical researchers and the media in the form of scans as well as prints from his library of original film, glass negatives, and transparencies. Norm Gholston is the author of *Portland's Slabtown*, also by Arcadia Publishing and written with Mike Ryerson, Tracy J. Prince, and Tim Hills, detailing the rich history of the Northwest neighborhood. He resides in Portland.

Also, thanks to Julie Osborne with the Oregon Parks and Recreation Department, Austin Schultz from Oregon State Archives, and county surveyor Vance Swenson Clatsop, who were all extremely helpful gathering what they could. And of course, thank you to my ever-patient and friendly editor at Arcadia Publishing, Matt Todd, who understands that not everyone loves computers! And pulling back into the loop, two certain men from a very long time ago (in the late 1800s) had an incredible vision of what this little slice of heaven called Cannon Beach could someday be; thanks to the original remittance men and vision seers Herbert Frederick Logan and Joe Walsh and all the other people who made Cannon Beach one of their favorite places to be.

INTRODUCTION

Cannon Beach is a very small town quietly nestled just off Highway 101 along the Oregon coast. It has been called one of the "World's 100 Most Beautiful Places" by *National Geographic* and named one of "The 100 Best Art Towns in America" by author John Villani—and rightly so.

The city of Cannon Beach is located on the Pacific Northwest coast, 80 miles west of Portland and 25 miles south of Astoria. Cannon Beach is surrounded by the Oregon Coast Mountain Range, ocean beaches, and rivers. Only four miles in length, and with a population of less than 2,000 residents, Cannon Beach is a popular and picturesque town that somehow caters to over one million visitors annually.

I often wondered in the too-short years I lived there with my son and actually called it our home—how can this miniscule city with a population of so few residents and a shopping span of less than eight city blocks be so amazing that it lures so many visitors each year to its sandy shores and grey weathered buildings?

But in my heart, I already knew the answer.

The town is simply magical.

Just what is so magnetic about the town? It is the emotional surge you get as you walk down those misty, romantic streets late at night or with your family and friends during the candy-scented day, knowing that you never want to leave. Life seems simpler, more beautiful, quieter, and more relaxed here. People stroll leisurely along, holding hands, enjoying an ice cream cone or a latte, laughing and soaking up the beauty, day-dreaming of building a fire later on the beach. The salty air frizzes their once-tame hair, and sand is found within every shoe, but no one is bothered by these things. Why?

Because they are at Cannon Beach with the legendary Haystack Rock!

The soaring rock developed between 13 and 35 million years ago when large eruptions occurred far away near Lewiston, Idaho, sending extensive flows of lava across Washington and toward the Pacific Ocean. These layers of basalt were hundreds of feet thick. Some poured right into the ocean and spread out for dozens of miles. In some spots (such as Haystack Rock), these flows re-erupted through thousands of feet of mud, essentially becoming miniature volcanoes. Later, as the Coast Range lifted, so did these massive flows, creating the monuments we adore today such as Tillamook Head and Haystack Rock.

Our earliest explorers, Lewis and Clark, stumbled upon Cannon Beach on January 8, 1806. They found the area beautiful and described it as such in their journals: "We have a view . . . which gives this Coast a most romantic appearance." Even before Lewis and Clark, the beginnings of Tillamook County started in August 1788, when Capt. Robert Gray anchored in the nearby bay and thought he had found the "Great River of the West." This was the first landing on the Oregon coast, and it was not until four years later that Gray found the mouth of the Columbia.

When Lewis and Clark arrived, a group of Indians had a thriving settlement at Indian Town Beach (now called Indian Beach). The Indian population of Tillamook County was estimated

at 2,200 in 1806, but by 1849, it had dwindled to 200 due to contagious diseases introduced by white settlers.

In the late 1800s, there was keen interest in developing the region from several British immigrants. Herbert Logan, Joseph Walsh, Jack Atsbury, and others were determined to make the area a thriving tourist town. In 1890, they teamed up with business associates from neighboring towns and developed a plan to open up the area for tourism. Herbert Logan and other investors funded the bumpy, one-wagon Elk Road—a treacherous, winding, and muddy path leading from Seaside to Cannon Beach. With the first part of the town's plan becoming a reality, this new road soon created a way for others to enjoy this little beach town. People came from Astoria, Tillamook, and as far away as the Willamette Valley looking for summer cottages. In 1897, Logan filed for a license to sell liquor and decided to live permanently at Cannon Beach at his Elk Creek Hotel. The town did indeed thrive.

Today, as people walk the streets of this small beachside town, they can still see these small cottages built by the first struggling residents and remittance men of Cannon Beach. The picturesque cottages are now over 100 years old, their old wooden floors creaking with stories one wishes they could tell. And now, more than 200 years after Lewis and Clark first fell in love with Cannon Beach's beauty, and after remittance men who were bent on creating a thriving tourist destination out of nothing, the bustling beach town still welcomes and embraces tourists and captures the heart of everyone who visits.

Visitors and locals make it a point to walk the sandy shoreline at low tide, letting the cool waves splash against their toes. The tide pools are home to dozens of beautiful pastel-colored starfish, the squishy jelly-skeleton of an anemone, and hundreds of tufted puffins that make Haystack Rock their home.

This gigantic rock gets its picture taken more than a famous movie star. It was in the opening scene of the movie *Goonies*, in Steven Spielberg's hit *1941* and pops up in Arnold Schwarzenegger's comedy *Kindergarten Cop* and in some scenes from *Free Willy*.

This book introduces those who so long ago believed in this tiny town tucked away from everything with no real access, labored hard, and spent their money to turn it into the incredible place people from all over the world love. Every day, people enjoy just sitting on the beach sifting the warm sand through their fingers, gazing at Haystack Rock and the Needles, and listening to the dozens of seagulls caw. Imagine what it was like years ago, when only a handful of people believed the town could be as spectacular as it is today.

Picture it.

Now, let's see the dream through their eyes for a spell, shall we?

One

THE CANNONS
AND THE COASTLINE

What we now know as Cannon Beach has had many different names: Seal Rock, Ecola Creek, Elk Creek, Silver Point Cliffs, Arcadia Beach, Glenwarren, Canyon View Park, Norrlston Park, Bald Hill, Sylvian Park, Lion Rock, and Brighton Beach. The current name became official in 1955.

In 1846, when Lt. Neil Howison sailed the USS *Shark* into the mouth of the Columbia River, he soon encountered trouble. He ordered the masts to be chopped off and the cannons pushed overboard to lighten the ship, but it broke apart anyway, dropping all the cannons into the sea.

In the 1860s, John Hobson and his business partner M. Eberman regularly spotted a cannon in a creek as they drove cattle to Tillamook, but never retrieved it. Hobson and Eberman both owned and sold Cannon Beach property, and in the 1880s, sold land to Herbert Logan and James Austin. Logan was one of the original remittance men and was crucial in the early development of Cannon Beach.

James Austin owned the largest hotel in Seaside, the Austin House Hotel. In 1890, he sold it to build a new hotel and post office near the present-day Arch Cape. Austin spent a considerable amount of time and money looking for the cannon, but died in 1894 before they were rediscovered.

Finally, in January 1898, a mail carrier named George Luce found and retrieved a cannon. As reported in the *Daily Morning Astorian* on January 29, 1898, "mail carrier Luce . . . saw a funny substance in the creek in front of Mrs. Austin's house. It did not look like a rock, and upon investigation he found one of the old brass cannon embedded in the creek from which Cannon Beach derives its name. Nothing much is known about how it got there. The late John Hobson and M. Eberman both saw the cannon in the creek quite often when on their way to Tillamook buying cattle." George Luce and others were successful in getting the cannon out of the creek, and it was displayed at the Austin House Post Office for years.

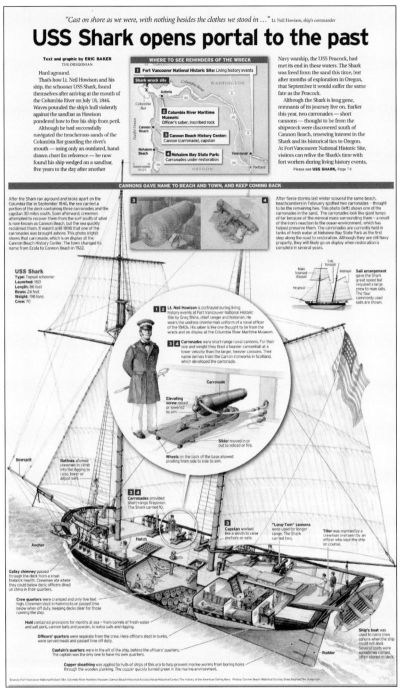

This sketch of the *Shark* details the ship's layout and explains its various parts and different compartments. The cannons aboard it were short range and fired a heavier cannonball at a lower velocity than the larger cannons used at that time. The *Shark* was originally launched in 1821, was 86 feet in length, weighed 198 tons, and carried a crew of 70 men. During the long, stressful evening in September 1846, the tattered *Shark* was destroyed by crashing waves, and it became a total loss. (Courtesy of the *Oregonian*, ©2008.)

In August 1846, the *Shark*, with Lieutenant Howison in command, finally arrived at the Columbia River. On September 10, the *Shark* ran aground and was battered in the crashing waves. Howison's crew survived the incident, and he was cleared later that year of any negligence in the wreck. He died in 1848, but evidence of the tragedy did not go away. Howison was posted under the US Navy's Pacific Squadron. (Courtesy of Norm Gholston and Thomas Robinson, OPS 29-66.)

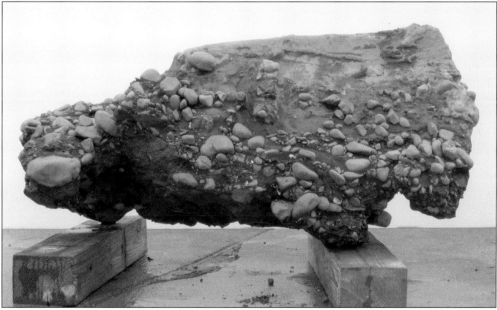

In 2008, a curious teenager, Miranda Petrone, was walking on the beach in Arch Cape with her family. She thought she had spotted a tree truck or lump of unusual sand nestled on the shoreline. Upon further investigation, she discovered it was one of the old cannons. It made its grand appearance on Presidents' Day, its discovery marking the arrival of two more cannons from the *Shark*. (Courtesy of Oregon Parks and Recreation Department, Oregon State Archives.)

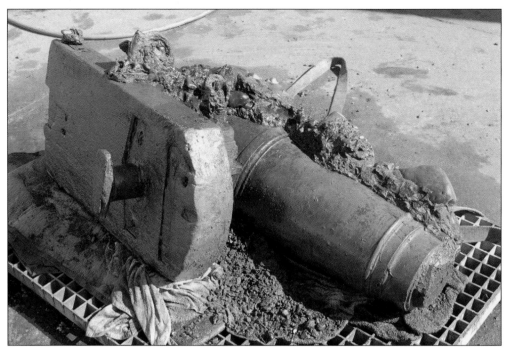

During restoration, the cannon's wood and metal parts were first exposed and then separated so they could be treated to resist corrosion. The *Shark* spent 18 years sailing the Atlantic Ocean combatting the slave trade near Africa and warding off piracy near the West Indies. Before her final misfortune, she sailed to the Pacific Ocean and became the first US warship to cruise east to west along the Straits of Magellan. (Courtesy of Oregon Parks and Recreation Department, Oregon State Archives.)

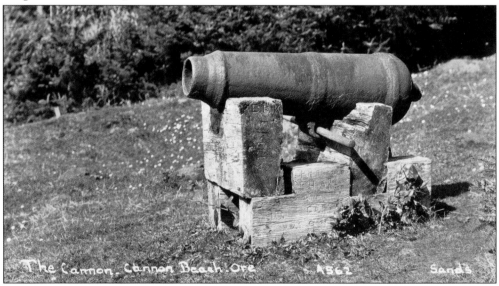

In 1891, James P. Austin built the first post office and hotel at Arch Cape, and was always searching for the lost cannon. Austin heard that one was possibly buried in a nearby stream, and the rumor is that he spent a lot of time and money trying to find it, but unfortunately never did. Austin died in 1894. (Courtesy of Norm Gholston and Thomas Robinson, OPS-29-05 A562 Sands.)

This aerial photograph of Cannon Beach was taken in 1939. In the 1930s, Cannon Beach had a very small population of just 125 residents. In 1945, Mel Goodin purchased and platted the land known as Cannon View Park. To make way for home sites, the cannon needed to be moved, so Van Vleet Logging donated one acre of land to the state on which to place them. The Oregon State Department of Highways prepared a site on the east side of Highway 101. (Courtesy of the City of Cannon Beach.)

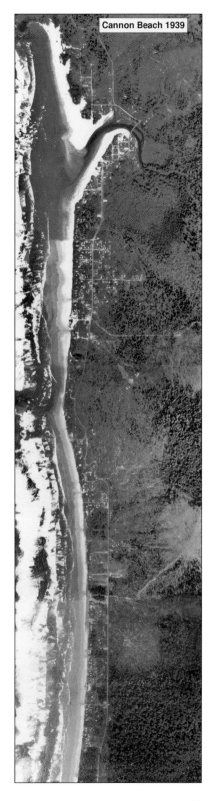

Cannon Beach 1939

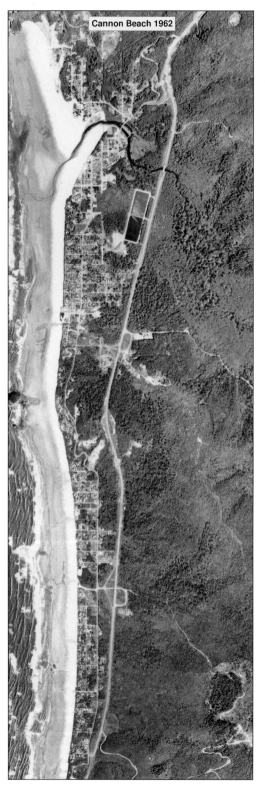
Cannon Beach 1962

This aerial view of Cannon Beach was taken in 1962. The population experienced its biggest growth in the 1960s, jumping from 125 residents to 495. Some things never change; people still stroll peacefully down the beach with friends, family, and loved ones, enjoying beautiful Cannon Beach. It is an incredible four-mile stretch of sand that can be accessed at 44 different points in the city. (Courtesy of the City of Cannon Beach.)

This aerial photograph of Cannon Beach was taken in 1977, by which time the population had grown to 779. Since Lewis and Clark first visited this spot, people have been falling in love with the beauty of Cannon Beach and Haystack Rock. A curious little town with less than 1,700 residents, it still gets over one million tourists per year due to its fantastic beauty, charming lifestyle, great food and atmosphere, and unusually friendly people. Haystack Rock is as famous as Mount Hood, the Grand Canyon, or any other breathtaking and beautiful natural feature. (Courtesy of the City of Cannon Beach.)

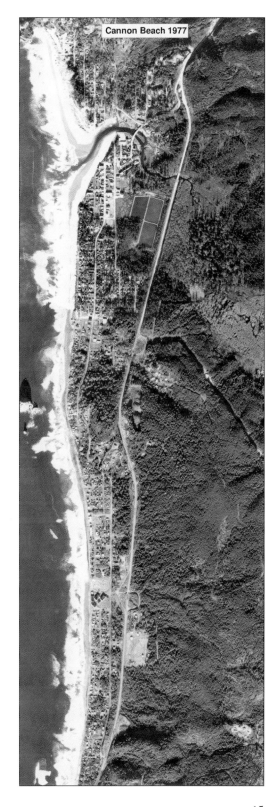

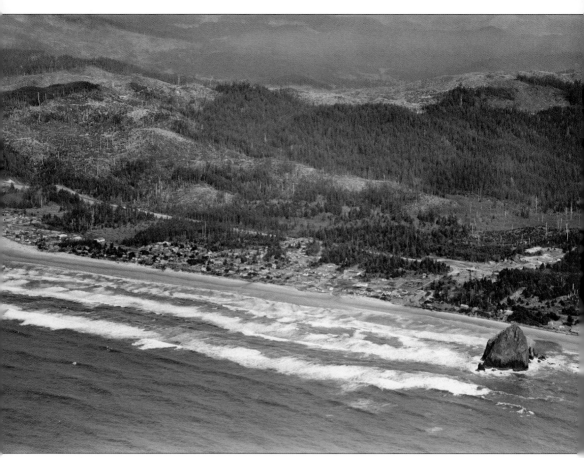

This bird's-eye view from 1951 shows the coastline from over the ocean. Haystack Rock's story began millions of years ago, when volcanic lava from eastern Oregon flowed west toward the Pacific Ocean. When this lava reached the sea, it descended into the soft ocean floor, pooled in spots, and pushed to the surface. After the tsunami of 1964, locals brainstormed on to how to draw attention to Haystack Rock and encourage visitors back. One idea was to light up Haystack Rock at night. The power company was persuaded to run a line to the rock and set up two large lights. The lights were only lit for one night, as they terrified the local seabirds, which swooped over the town, covering it in droppings. (Courtesy of Thomas Robinson, ackroyd 02782-22.)

Two

THE BEACH DRAWS THE BUSINESSES

From 1870 to 1930, the sons of wealthy Englishmen came to North America to work but still received money from back home, creating the term "remittance men." Most were hard workers and played a big role in the startup of Cannon Beach. The remittance man period lasted until the beginning of World War I.

Two such men, Herbert Logan and Joe Walsh, came to the beautiful Oregon coast with the hopes of developing it. Unfortunately, this section of the beach had no main road and was basically inaccessible, but these visionaries were not easily disillusioned. The beauty of Haystack Rock and its coastline enriched their faith.

By 1890, about 50 families occupied the nine-mile stretch of land between Tillamook Mountain and Neahkahnie Mountain, of which a few were original homesteaders, such as Eberman, Hobson, and Austin, who were very important in the development of the town.

Niman Eberman, born in Tennessee, arrived in the Northwest in October 1843. In the 1850s, he married Emma Hobson, sister of John Hobson, and they had 11 children. He sold much of his land to Herbert Logan and James Austin in the 1880s. Eberman was also the father to Austin's first wife.

James Austin was born in Canada and traveled to the California coast in 1871, then to Clatsop County. He owned one of Seaside's largest hotels but sold it in December 1890 and used the money to have lumber shipped in to build the first hotel and post office in Cannon Beach, near Arch Cape.

Herbert Logan organized the Elk Creek Road Company in 1890 with a group of Astoria businessmen. He and other investors financed the first wagon road that ran from Seaside over Tillamook Head and operated it as a toll road. The *Daily Morning Astorian* of June 25, 1890, reported that the new road would be a great convenience:

The residents of the southwestern part of the coastline in the county are at last to have a road. Several public spirited citizens, grown tired of waiting, have subscribed the money themselves and have contracted with CW Carnahan to build about 6 miles of road from the Seaside down to Necanicum to Elk Creek. The contract price is $3,000. Herbert Logan gives $1,500, the proprietors of Seal Rock Beach $600, and other parties $900. It will give an outlet to about 50 families and also a straight road to Tillamook.

While Logan invested his money in Cannon Beach, he and other remittance men, Jack Atsbury and Harry Bell, also teamed up to survey and plat most of the area. In 1892, on Logan's 158-acre homestead (now called Ecola Creek), Logan constructed and operated the Elk Creek Hotel. Later, the men platted the area from Elk Creek to Haystack Rock and offered plots that measured 50 by 100 feet for just $100 each. To encourage even more excitement from travelers turned homesteaders, they offered to refund the $100 to whoever constructed the first home.

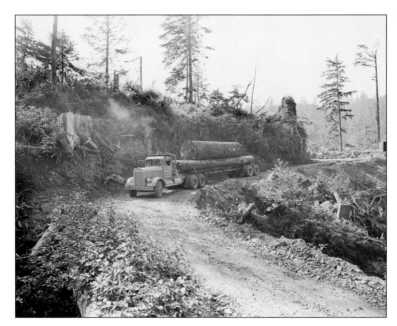

The Van Vleet Logging Company was responsible for clearing a large portion of the area of Cannon Beach. In September 1953, a loaded Van Vleet log truck is coming down a steep curve on a logging road from a clear-cut project above Cannon Beach. (Courtesy of Thomas Robinson, ackroyd 04645-207.)

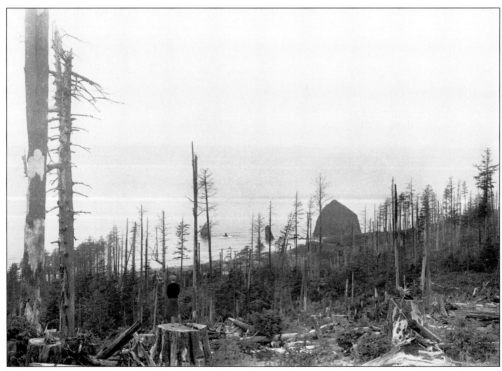

A large area of the forest was logged and burned near Haystack Heights in Cannon Beach about 1936. Gladys Smith, wife of photographer Larry Smith, stands on top of one of the recently cut trees overlooking Haystack Rock and the shoreline. Some of the local spruce trees measured almost seven feet in diameter. The population of Cannon Beach between 1930 and 1950 remained 125 residents. (Courtesy of Thomas Robinson, 0001-B42.)

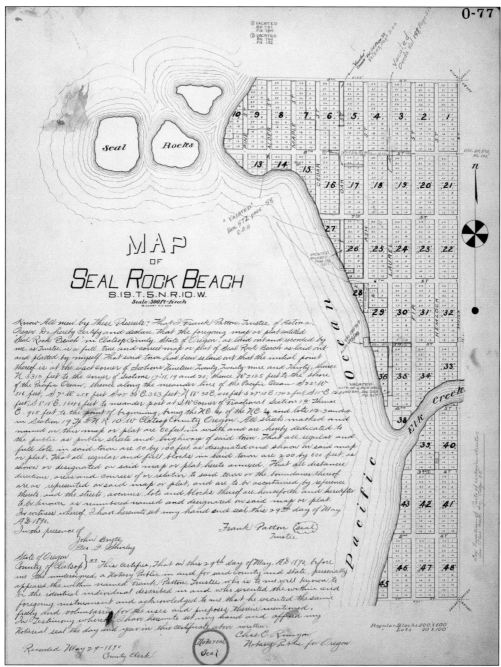

This map of Seal Rock Beach created by Frank Patton is dated May 29, 1890, and shows his proposed plat of the town. The lots each measured 50 by 100 feet, and the full blocks measured 200 by 600 feet. At this time, an average home-size lot in Clatsop County would sell for approximately $80. The town was still in dire need of a good road. (Courtesy of Clatsop County Surveyor, Clatsop County Town Plat Records.)

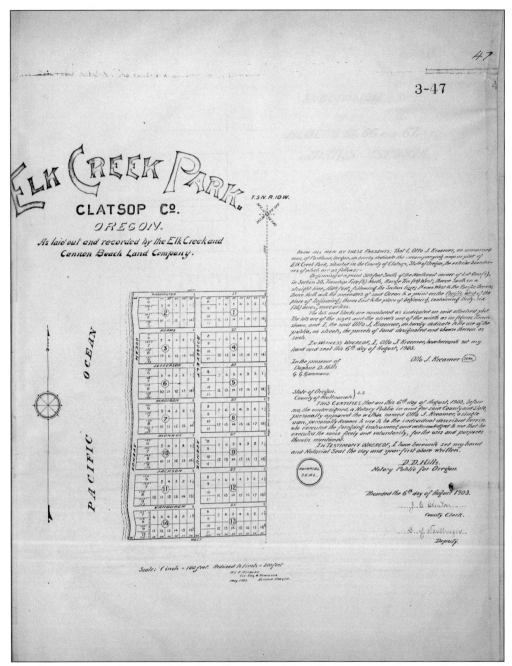

Another proposed plat created by Otto Kraemer of the Elk Creek and Cannon Beach Land Company, dated August 6, 1903, was called the Elk Creek Park. The well-loved nearby park today hosts over 150,000 hikers annually. (Courtesy of Clatsop County Surveyor, Clatsop County Town Plat Records.)

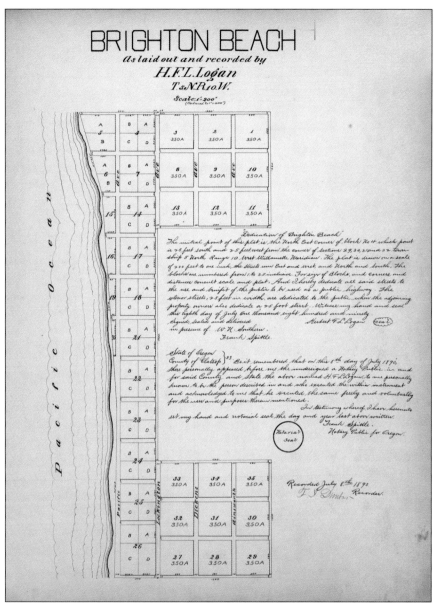

The Brighton Beach plat map, sections 29, 30, 31, and 32, was recorded by Herbert F.L. Logan himself. The *Daily Morning Astorian* recorded the transfer of southeast quarter-section 33 to Logan on October 25, 1883, for the sum of $1,050. Logan was one of the most important men in the building of Cannon Beach. Although no photographs of Logan could be found, his signature dated July 8, 1890, is visible here. Logan organized the Elk Creek Road Company in 1890 with a group of local businessmen. He then helped finance the creation of the first wagon road and also invested in many of the small businesses in town. An unusual report from the *Daily Morning Astorian* dated May 22, 1895, claims, "a peculiar story comes from Brighton Beach, where a few months ago, during a fearful storm, a great bank of foam, fully 80 feet in height!, gradually drifted up from the boiling surf and moved fully 100 feet into the forest. To those who were fortunate enough to witness it, a magnificent sight was presented." (Courtesy of Clatsop County Surveyor, Clatsop County Town Plat Records.)

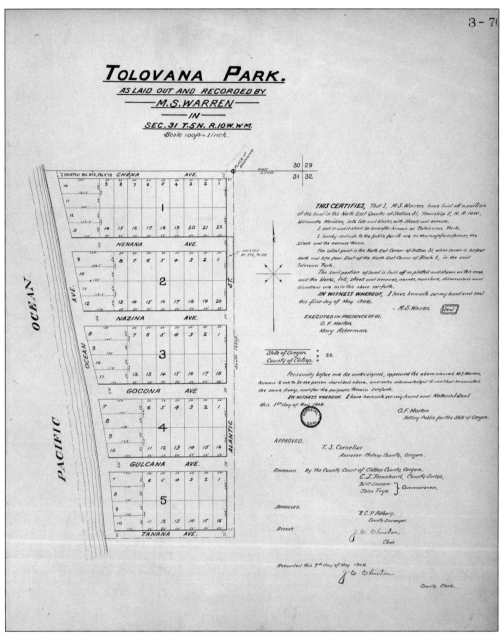

The Tolovana Park section of Cannon Beach was platted by Mark S. Warren on May 7, 1908. The Warren families were very prominent in the creation of the town. As stated in the *Sunday Oregonian* of August 20, 1911, "Mark S. Warren, pioneer residents of Cannon Beach, have just opened 'The Warren' a picturesque log hotel on the ocean beach, near Haystack Rock. Among the first guests at the new hotel were Oregon's Governor West." On December 31, 1911, the paper reported, "the hotel is unique in many respects. It affords a perfect view of the coast line as well as the ocean, and is every way suggestive of out-of-door life. The decorations are exclusively of hunters' trophies." Gov. Oswald West purchased 20 lots near Haystack Rock in 1912. When West visited the area, he enjoyed staying at the Warren Hotel, and his name appears on the old hotel registry. (Courtesy of Clatsop County Surveyor, Clatsop County Town Plat Records.)

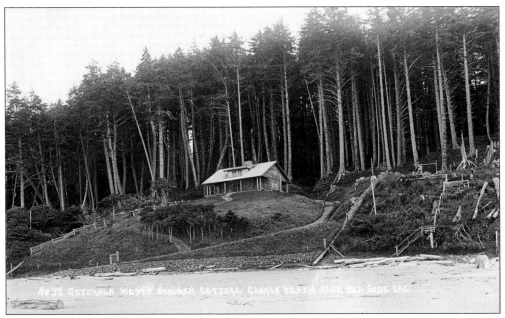

Governor West had fallen in love with Cannon Beach during his time as a banker in Astoria. West was responsible for making the state's beaches public, passing legislation in 1913 declaring the shoreline a public highway. By 1913, West had finalized his plans for a log house and barn. The original home was destroyed by fire in the 1990s but was rebuilt, as seen here from the beach just south of Haystack Rock in its original location. (Courtesy of Norm Gholston and Thomas Robinson, OPS-29-20.)

This beautiful photograph shows Manzanita from Neahkahnie Mountain near Arch Cape, south of Cannon Beach. Former Oregon governor Oswald West secured almost 400 miles of Oregon shoreline to be set aside for public use. The first portion of the park was a gift of 120 acres from E.S. and Mary Collins on November 12, 1931. Early trail improvements were made by the Civilian Conservation Corps (CCC) between 1939 and 1941. (Courtesy of Oregon Parks and Recreation Department, State Archives.)

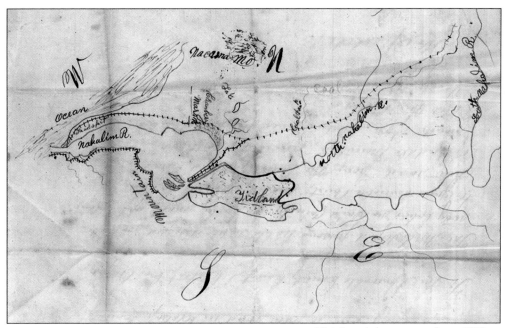

This hand-drawn map from 1870 shows the proposed road from the base of Saddle Mountain (off Highway 26) to the Nehalem River. It also notes the Nehalem Spit, where a Spanish ship carrying a load of beeswax met its fate. It is thought to be either the *Santo Cristo de Burgos* (disappeared in 1693) or the *San Francisco Xavier* (disappeared in 1705), making it the earliest known shipwreck in the Pacific Northwest. (Courtesy of Oregon State Archives, 1029113.)

The original application, dated March 1, 1870, for the construction of a road was filed with the Clatsop County Court by H.B. Parker along with a number of other local signatures. A good road to the beach was extremely important to the seaside communities not only for travel but also for tourism. The old roads to the beach were horrible, with multiple twists and layers of thick mud. (Courtesy of Oregon State Archives, 1011273, Clatsop County Road Survey Records 1851–1911.)

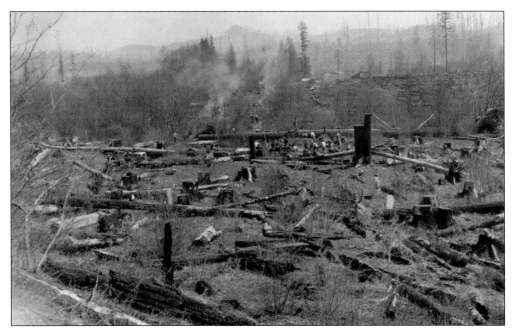

These before-and-after photographs show an area being cleared for the new Wolf Creek Highway (now called Highway 26 or Sunset Highway) in April 1936. Construction of the highway began in 1933, and it opened to the public in September 1941. The 40-man crew was armed only with axes and two-man saws to bring down the trees and cut them up. Stumps and debris were typically just burned at the site. The impressive hard work on this site was completed in just seven days. Both the Works Progress Administration (WPA) and the CCC participated in the construction during the Great Depression. The name "Sunset" is from the shoulder sleeve insignia and nickname of the 41st Infantry Division, to which the highway is dedicated. (Both, courtesy of Oregon State Archives.)

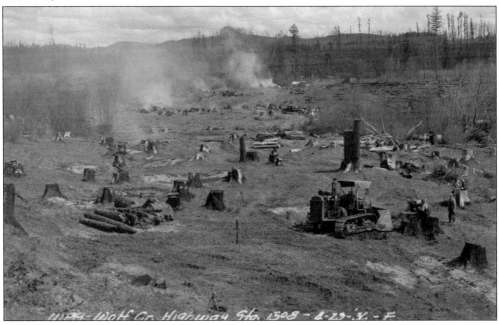

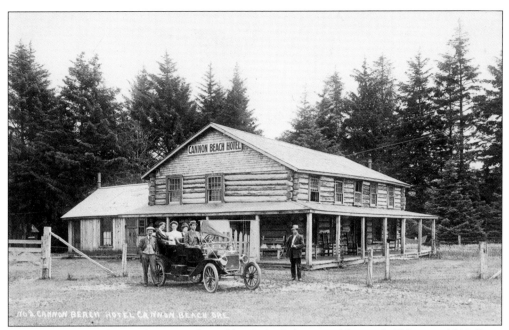

The Cannon Beach Hotel was purchased by D.A. Osburn and his wife, Edna, in 1913. Pres. Woodrow Wilson signed the register in 1914. In 1943, the US Coast Guard used the 10-room building as a barracks. One year later, it was sold to the McNeills, who created the Cannon Beach Conference Center. (Courtesy of Thomas Robinson, OPS 29-02.)

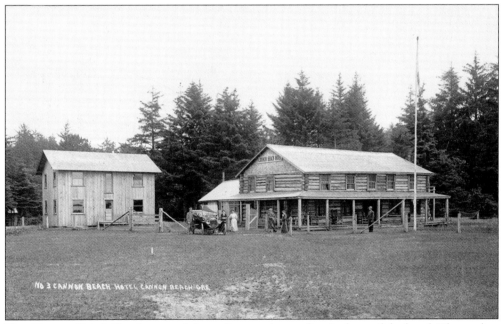

This Cannon Beach Hotel postcard shows five people standing in front of the hotel. The car has a 1912 Oregon license plate. Back then, travelers left Astoria by train to Seaside, were met at the train by the hotel's own stage, and then traveled another 45 to 90 minutes to get to Cannon Beach. (Courtesy of Norm Gholston and Thomas Robinson, OPS 29-03.)

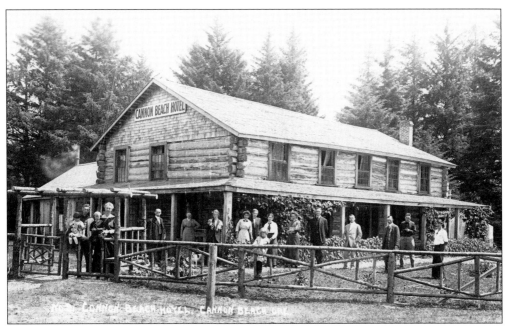

Here is another beautiful Cannon Beach Hotel postcard, this one from around September 1914. The Cannon Beach Hotel, called Hotel Bill in 1904, was built from logs that washed ashore from an old log raft. While on his campaign trail, President Wilson arrived as a welcome guest in Cannon Beach. (Courtesy of Norm Gholston and Thomas Robinson, OPS-29-01.)

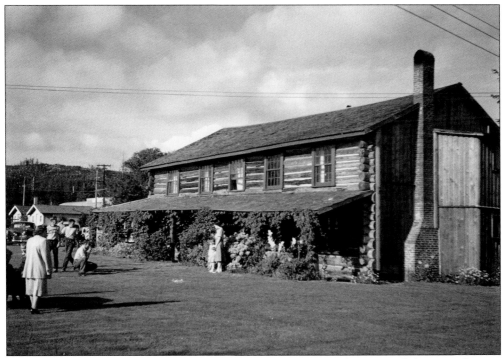

The Cannon Beach Conference Center is pictured in August 1952. (Courtesy of Thomas Robinson, CS00931-19.)

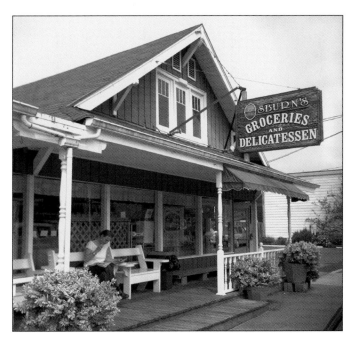

Osburn's Grocery on Hemlock Street operated from 1915 and was one of the oldest structures in Cannon Beach when it was demolished in late 2003. In 1942, Osburn's was renamed Dennon's Dry Goods. In the 1970s, it became Osburn's again and accommodated a grocery store and ice cream shop. Here, Jenny Ankeny is reading a newspaper in front of Osburn's in May 2003. In 2004, the Coaster Village property was developed on the site. (Courtesy of Thomas Robinson, TR-457.)

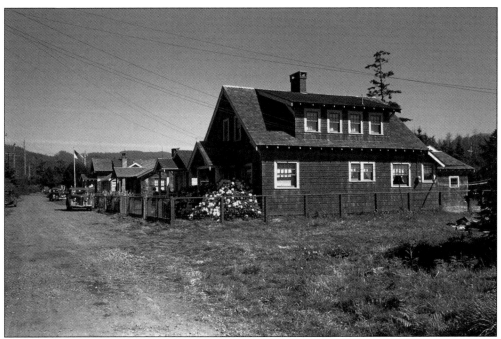

This nice photograph looks east on West Jefferson Street in Cannon Beach around 1941 or 1942. The Bueermann cottage is on the right at 179 West Jefferson Street and is still standing, presently the second house from the beach. (Courtesy of Thomas Robinson, CS00036-17.)

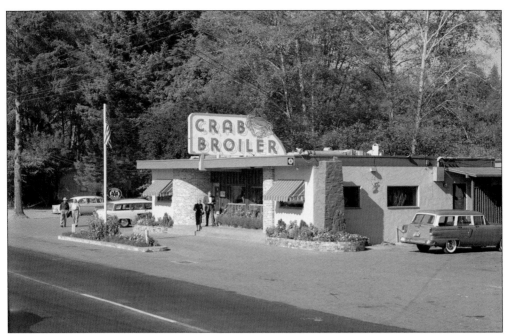

The Crab Broiler, pictured in September 1955, was located at the Cannon Beach junction of Highway 26 and US 101, four miles south of Seaside. Bill Daggatt, Jay Brown, and their wives, June and Lucille, bought the restaurant in 1946. The Crab Broiler served up local favorites for almost 40 years: fried chicken, great seafood, and delicious pies. At times there was a one-hour wait to eat there. (Courtesy of Thomas Robinson, ackroyd 06354-74.)

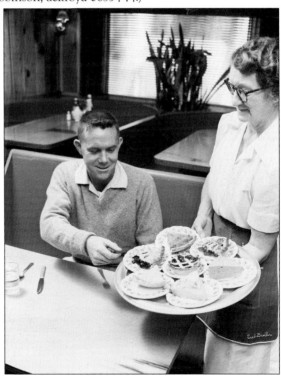

The Crab Broiler hosted a fabulous "choose your own pie" tray and sold over 1,000 pies each month. Here restaurant owner Bill Daggatt (left) tries one on September 21, 1955. The team of Daggart and his brother-in-law Jay Brown started the Crab Broiler in 1946. Later, the brothers also started Mo's Restaurant in Tolovana. Many a high school student earned great tips and spending money during the years the Crab Broiler was open. (Courtesy of Thomas Robinson, ackroyd 06354-13.)

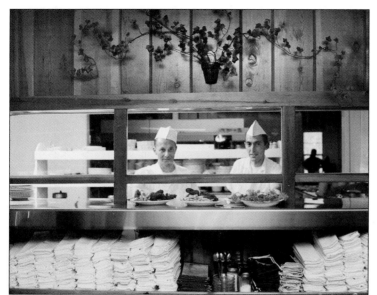

The two proprietors of the Crab Broiler split the never-ending cooking chores in September 1955. Here Jay Brown (left) and Stan Prouty serve up food with a big smile and friendly attitude. (Courtesy of Thomas Robinson, ackroyd 06354-18.)

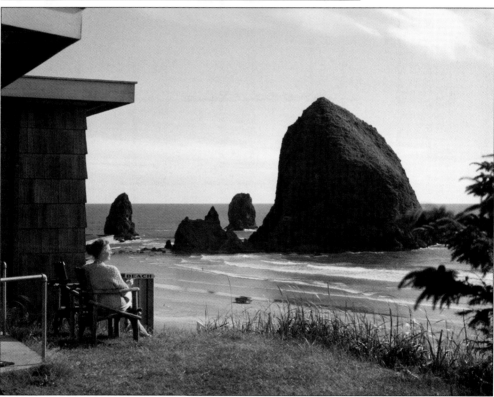

This gorgeous photograph shows Haystack Rock from the Surfview Apartments in June 1957. The rock can be seen prominently in the 1971 film adaptation of Oregonian Ken Kesey's novel *Sometimes a Great Notion* during the scene where the Stampers brawl with the union workers. It can also be seen in the opening scene of *The Goonies*, when the Fratellis are fleeing. Haystack Rock can also be seen in the 1979 movie *1941*, directed by Steven Spielberg. (Courtesy of Thomas Robinson, ackroyd C00323-1.)

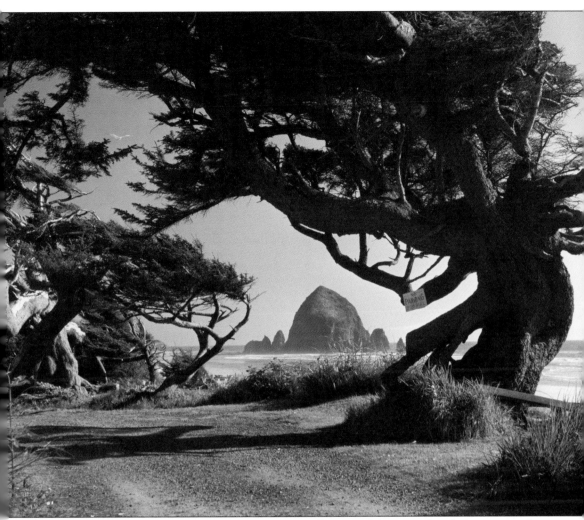

Cannon Beach's famous original Wedding Tree, actually a set of three windswept fir trees, used to be located on an Ocean Avenue loop connecting West Adams and West Washington Streets. The attractive tree, framing a picture-perfect view of Haystack Rock, served photographers for decades until about 1937, when branches and roots alike were sawn away to remove obstructions to automobiles on the narrow lane. This was approximately where Ecola Creek empties into the Pacific, near the beginning of the Presidential Streets and Kramer's Point. By the time this photograph was taken on May 20, 1951, the trees were heavily scarred by the amputations, and one of the stumps was used to display a "No Parking" sign. Despite the continuing physical deterioration, the three trees lasted into the 1970s, when they were removed and the road was paved. (Courtesy of Thomas Robinson; deLay510520-01/02.)

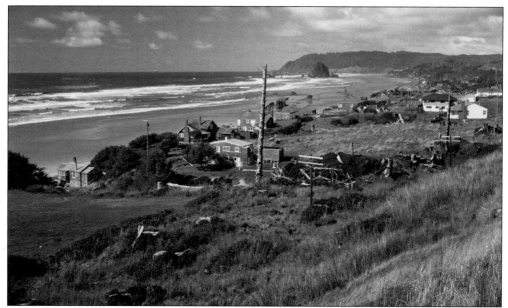

This bird's-eye view shows Cannon Beach around 1940, when there were still vacant oceanfront lots available. In the late 1890s, visitors set up tents on the shoreline and camped out during the summer months. One humorous article in the *Morning Astorian* from July 1895 reads, "won't be long before tents will be necessary to shelter the surplus of visitors . . . there seems no end to the discomforts one can put up with when 'roughing it' at the sea shore." (Courtesy of Thomas Robinson, CS01111-06.)

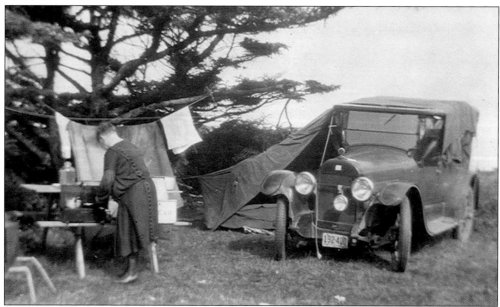

A woman does her laundry and cooking at her tent camp next to her automobile. In the early 1900s, the streets of Cannon Beach were made up of small clusters of cottages and tents, all surrounded by tall spruce trees. Other tent families would prepare a large tent area with a platform—a common summer residence for early Cannon Beach visitors. (Courtesy of the Oregon State Archives, 1000542.)

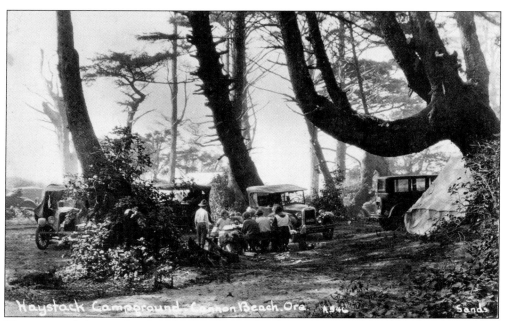

This postcard shows a family enjoying a picnic lunch together; on the back, it reads "Becker's Camp Ground 1927." Roy Becker was a major landholder in Cannon Beach during that time. (Courtesy of Norm Gholston and Thomas Robinson, OPS-29-06.)

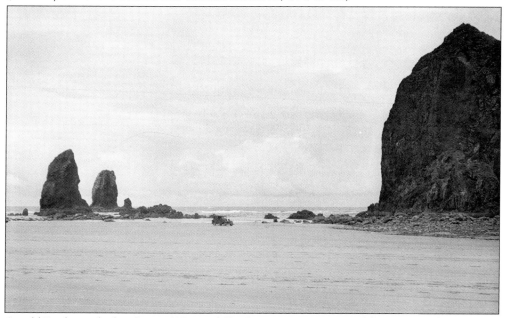

An old Ford is parked in front of Haystack Rock in June 1941. Joe Walsh, an original remittance man along with Herbert Logan (who built the Elk Creek Hotel), did many things to earn additional money to keep developing Cannon Beach. He often completed odd jobs, raised cattle, and also managed the Elk Creek Hotel. Walsh loved Cannon Beach and lived there until his death in 1923. Logan suffered from incurable paralysis, and by the summer of 1899 had become too ill to run the Elk Creek Hotel. He died on January 14, 1906, at 43 years old, and was buried at the family plot in Bournemouth, England. (Courtesy of Thomas Robinson, deLay410600.)

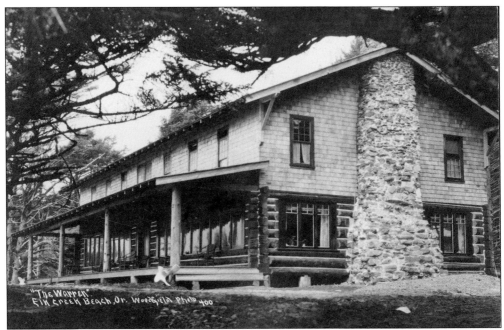

This Woodfield photograph shows the Warren House at Elk Creek Beach. The postcard has a postmark of August 5, 1915, and the imprint of Woodfield Photo in Astoria on the other side. (Courtesy of Norm Gholston and Thomas Robinson, OPS-29-13.)

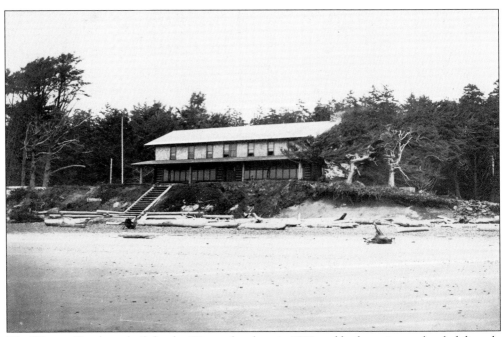

The Warren Hotel was built by the Warren brothers in 1911 and had a stairway that led directly down to the beach. Paul Bartels built many of the massive fireplaces in town, including the one in this hotel, and was paid $2 per day for his amazing stonework. Today, the Tolovana Inn is on the site of the old Warren Hotel. (Courtesy of Norm Gholston and Thomas Robinson, OPS-29-14.)

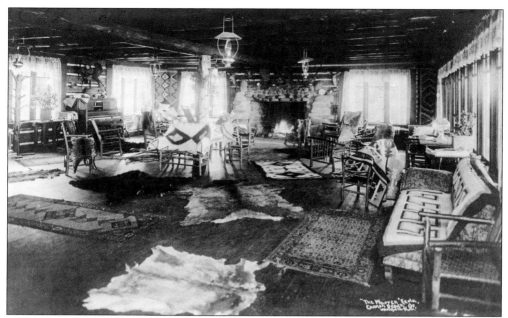

More visitors meant more hotels. In 1891, James P. Austin built the Austin House, which was both a hotel and a post office. In 1892, the Elk Creek Hotel was constructed by Logan. The Hotel Bill was constructed in 1904, and then the Warren Hotel (pictured) in 1911, soon followed by the Ecola Inn in 1913 to welcome eager visitors. (Courtesy of Thomas Robinson, Woodfield photo/OPS-29-15.)

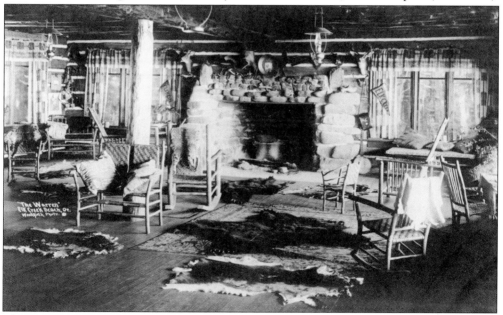

The Warren Hotel had a fireplace that was nine feet wide inside, constructed by Paul Bartels using stones from the beach. The hotel had 16 rooms with indoor running water, and Governor West was the first registered guest. It was in operation until 1939; in 1941, the Coast Guard used it as barracks. It was demolished in 1971 to make way for the Tolovana Inn. This postcard bears a July 15, 1915, postmark. (Courtesy of Norm Gholston and Thomas Robinson, Woodfield photo/OPS-29-16.)

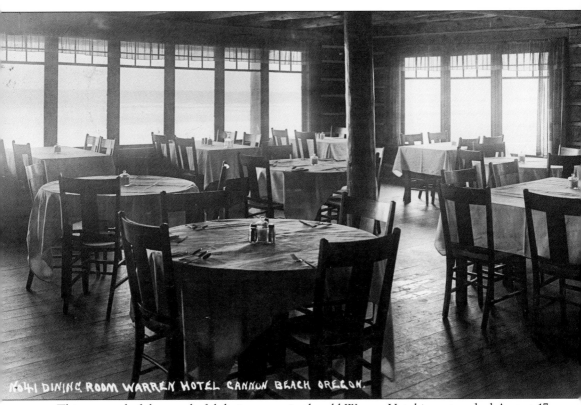

No.41 DINING ROOM WARREN HOTEL CANNON BEACH OREGON.

This postcard of the wonderful dining room in the old Warren Hotel is postmarked August 17, 1914. Locals spent hours lounging casually, drinking, and sharing gossip in front of its famous fireplace. The *Sunday Oregonian* of August 20, 1911, reports: "Captain W.E. and Mark S. Warren, pioneer residents of Cannon Beach have just opened 'The Warren' a picturesque log hotel," while the *Oregonian* of December 31, 1911, notes: "One of the most pleasant Christmas house parties was given by Mr. & Mrs. Warren . . . about 55 guests were present." The first piano ever brought to Cannon Beach was placed in the Warren Hotel. Another *Oregonian* article dated August 4, 1912, boasts: "Warren Hotel is providing the social center of the beach, because of its central location and spacious lobby, which seats 200 people. The Saturday night dances are enjoyed equally by the cottagers and the patrons of the hotel. The Wednesday evening musicals bid fair to become a regular event." (Courtesy of Norm Gholston and Thomas Robinson, OPS-29-17.)

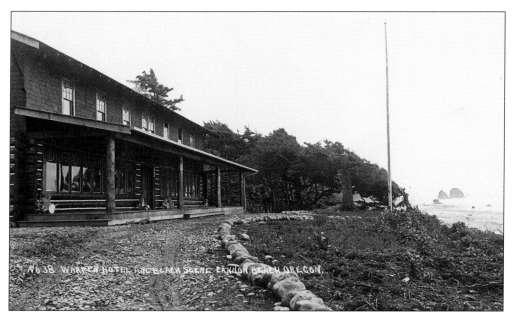

The Warren Hotel's extensive front porch area and flag pole are shown in this beach scene. In the early 1890s, brothers William and Mark Warren applied for a homestead claim in the Tolovana area. In order to justify their claim, the Warren brothers were required to build on the land, so in 1897, William and his wife, Emma Sayre, built a cabin on their 160 acres. The certificate was signed by President McKinley and now hangs in the entrance to the Warren House Tavern. (Courtesy of Norm Gholston and Thomas Robinson, OPS-29-18.)

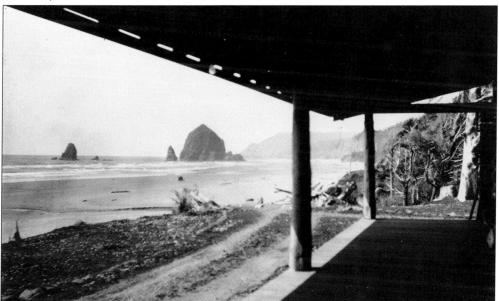

This spectacular view looks north at Haystack Rock and the Needles from the Warren Hotel's front porch. An article in the *Oregonian* dated August 4, 1912, reads, "Season lively at Cannon Beach! . . . The scenic beauties of this part of the coast draw many sightseers from Seaside and Gearhart. Every day the beach is thronged with stages and autos, which drive to Arch Cape and back." (Courtesy of Norm Gholston and Thomas Robinson, OPS-29-19.)

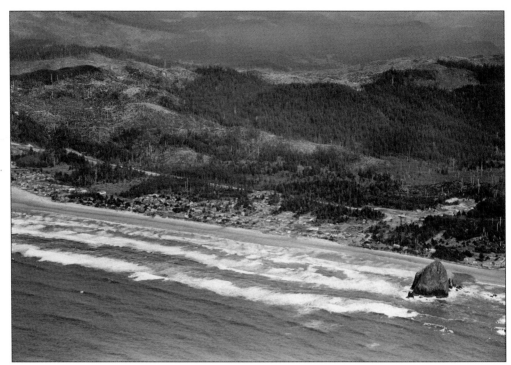

Midtown Cannon Beach is seen from the air in April 1951. The Cannon Beach Hotel, the American Legion building (both on Hemlock Street), and the old Van Vleet Logging Company (to the right of Gower Street, then named Division Street) can all be seen. (Courtesy of Thomas Robinson, ackroyd 02782-22.)

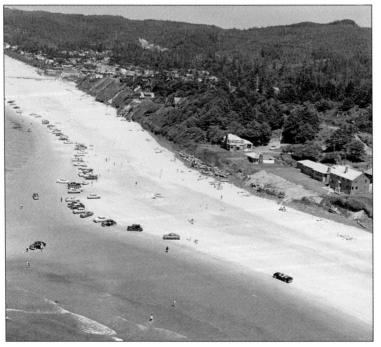

Many locals and tourists came to Cannon Beach to celebrate the Fourth of July in 1958. Today, Cannon Beach is the perfect spot for weddings, anniversaries, and any other celebration. The town offers a Fourth of July parade, sandcastle contest, cottage tour, dog show, art festival, whale watching, farmer's markets, and much more throughout the year. (Courtesy of Thomas Robinson, deLay 580704E-03.)

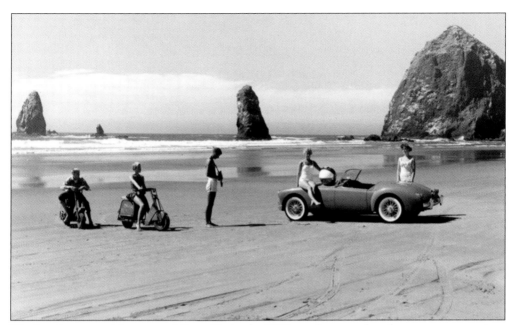

The beach was used for automobile traffic in the 1950s, and even today, there are some sections that people can drive on. Governor West signed the original Beach Bill in 1913, which was followed up by Gov. Tom McCall in 1967 finally clarifying where public land ended and private property began. (Courtesy of Oregon State Archives, 544756.)

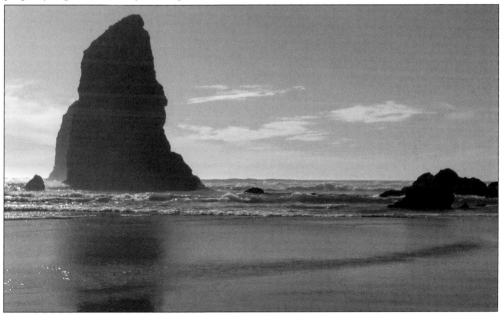

The Oregon Beach Bill guarantees that all land within 16 vertical feet of the average low-tide mark belongs to the people of Oregon and that the public has free and uninterrupted use to enjoy it. Governor McCall had a large role in the passing of this bill when he coordinated the flying of two helicopters over the beach with surveyors and scientists aboard. The incredible media coverage created a public demand for the bill, which was passed and signed in July 1967. (Courtesy of Oregon State Archives, 945965.)

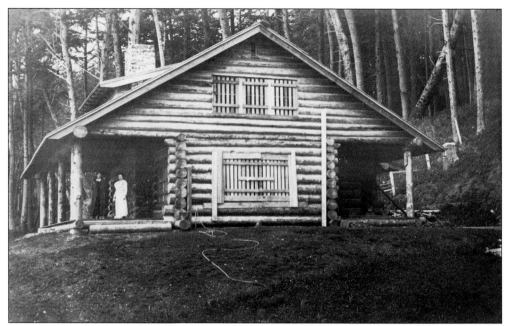

Two women stand on the front porch of the original Governor West Cottage posing for the camera. It is likely the woman in white is Oswald's wife, Mabel. In 1912, they purchased an acre of land, and by 1913, West had finalized plans for a log house. (Courtesy of Norm Gholston and Thomas Robinson, OPS-29-25.)

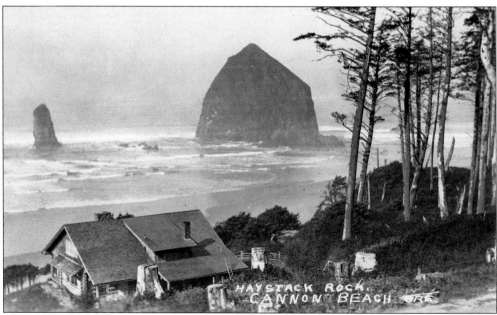

This is the incredible view of Haystack Rock from the Governor West Cottage on the cliff's edge. A 1958 ceremony honored former Oregon governor Oswald West and his great passion for protecting Oregon beaches by renaming Short Sand Beach after him. West's historic summer retreat is as recognizable to many visitors as Haystack Rock. (Courtesy of Norm Gholston and Thomas Robinson, OPS-29-24.)

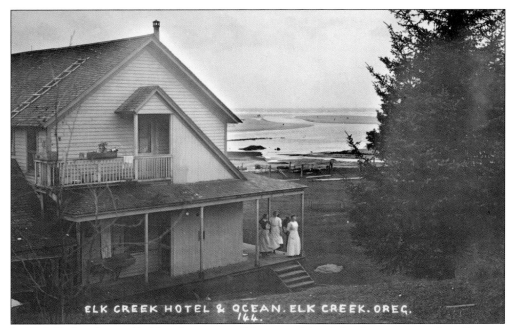

ELK CREEK HOTEL & OCEAN. ELK CREEK. OREG.

In 1897, Herbert Logan filed for a license to sell liquor and decided to live permanently at Cannon Beach at his Elk Creek Hotel. His partner, Joe Walsh, ran the hotel. On July 21, 1885, the *Morning Astorian* reported: "Frederick Logan and Joseph Walsh, ranchmen at Seaside, arrived in town on Saturday. They came via Tillamook and Forest Grove, making the trip in three and a half days. They represent the journey as a pleasant one, although the trails had to be opened at several points." (Courtesy of Norm Gholston and Thomas Robinson, OPS-29-56.)

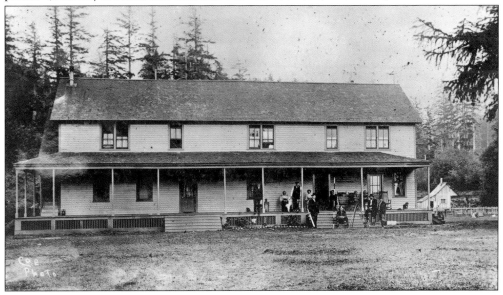

Logan organized the Elk Creek Road Company in 1890 with a group of businessmen and built the Elk Creek Hotel. The Elk Creek and Ecola area grew into a popular summer destination. On his 158-acre homestead, which spanned Elk Creek (now Ecola Creek) to near where the bridge stands today, Logan constructed and then operated the second resort hotel in Cannon Beach. (Courtesy of Norm Gholston and Thomas Robinson, OPS-29-57.)

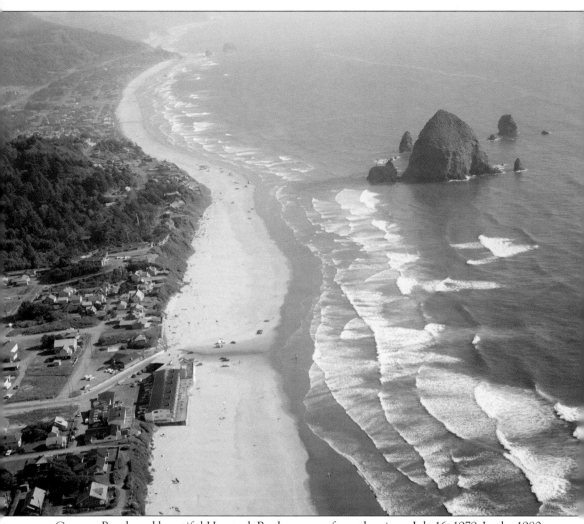

Cannon Beach and beautiful Haystack Rock are seen from the air on July 16, 1979. In the 1980s, the population of Cannon Beach finally grew to 1,187 residents. The large building on the beach is the Surfsand Resort, and the diagonal road that runs onto the beach is Ecola Court. The Wayfarer Restaurant is currently located there. Haystack Rock is one of the most photographed places in the state of Oregon. It rises 235 feet out of the sand and the sea at low tide and is home to a variety of sea-life and many birds, including tufted puffins, gulls, and cormorants. At low tide, starfish can be seen clinging to rocks in the tide pools. (Courtesy of Thomas Robinson, ackroyd C04842-6.)

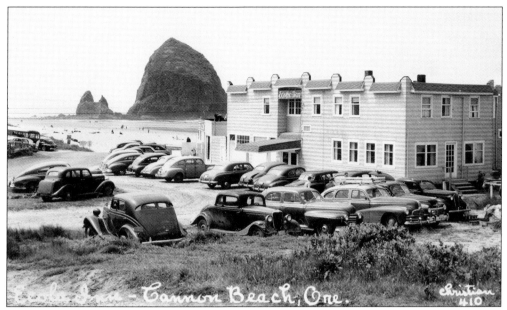

The Ecola Inn was built in 1913 and had a flagpole attached to an old tree stump. It was built by August Becker and his son, Roy, who both owned a lot of land in Cannon Beach. Carpenters at that time were paid just $4 per day and the cost to stay at the Inn was between $2.50 and $3.50 per night. In 1948, Emma Fowler bought the inn and had a pet parrot named Loleta, who became a mascot for the place. The Surfsand Resort is now at this spot. (Courtesy of Norm Gholston and Thomas Robinson, OPS-29-58.)

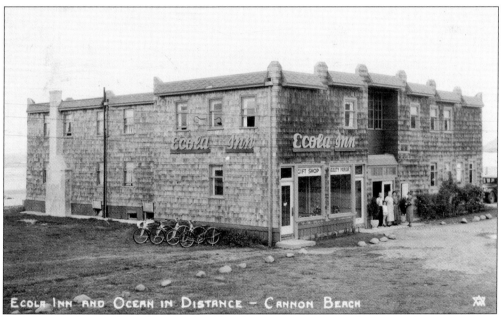

Ecola Inn was known for its longstanding Ping-Pong tournaments and one very obnoxious parrot. It had a wooden plank seawall. The Ecola Restaurant closed in the fall of 1976, and the owners converted to the motel business until 1981. It is now 13 oceanfront rental units. (Courtesy of Norm Gholston and Thomas Robinson, OPS-29-60.)

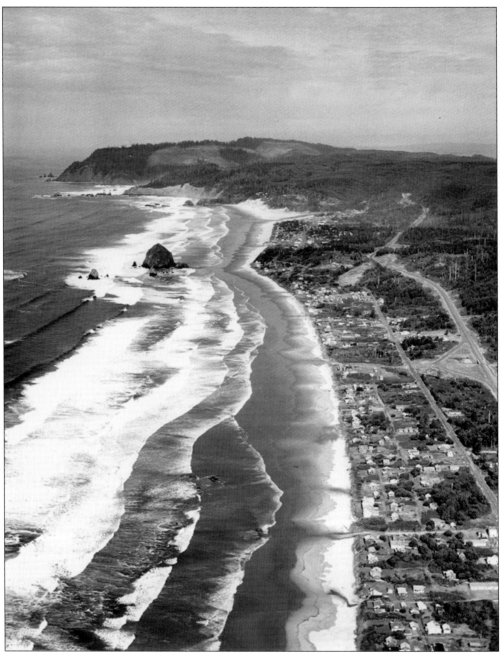

This aerial photograph shows the Oregon Coast Highway winding up to the slopes of Neahkanie Mountain. The legend of the coastal Indians (possibly the Nehalem clan) is that the mountain is seen as a sleeping warrior waiting to be woken from a slumber. The word Neahkanie translates to "the place of the supreme deity." The construction of the Neahkanie Mountain section of Highway 101 was completed in 1940 by WPA workers. It is said that the highway followed the route of an Indian trail that linked the Clatsop and Tilllamook people. (Courtesy Oregon State Archives, 10409787.)

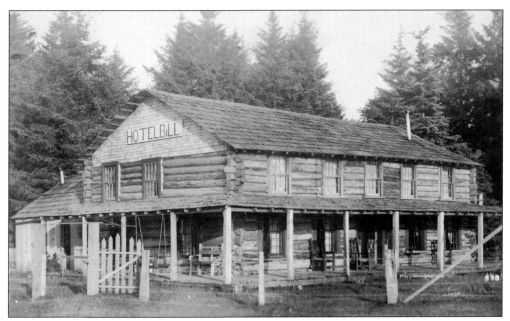

This old postcard from Hotel Bill is postmarked August 8, 1910. The handwriting reads, "This is the hotel where we are staying." The hotel was built by George Bill in 1904 from some beach logs that washed ashore. In 1910, the official post office for Ecola, Oregon, was located in the hotel, and it became the hot spot for locals to swap gossip. (Courtesy of Norm Gholston and Thomas Robinson, OPS-29-39.)

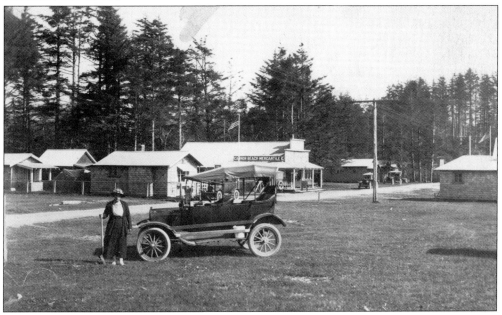

This photograph dated 1922 shows a woman and her car. In the background is Cannon Beach Mercantile. Osburn's Grocery operated from 1915 to 2004. The adjoining building was then the Cannon Beach Mercantile. In 1974, the Osburns bought the businesses back and turned the north side into Osburn's Grocery and the south side into an ice cream shop, which is operating on the site today. (Courtesy of Norm Gholston and Thomas Robinson, OPS-29-07.)

Gov. Tom McCall stands in front of the Surfsand Motel in 1967. McCall was agitated by Bill Hay (the motel's owner), who demanded this section of the beach be only for his guests. His employees told other tourists to get off his "private beach." This started a snowball effect, and soon authorities were arguing about the boundaries for public shoreline access. The result was the Beach Bill that protected public use of beaches. (Courtesy of Western Oregon University Archives.)

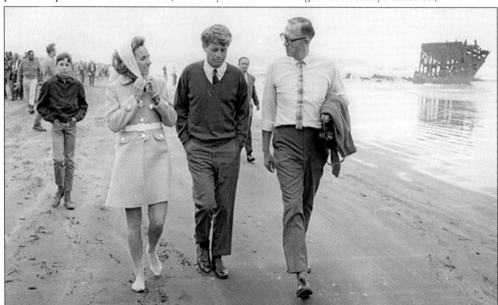

State treasurer Bob Straub walks near the wreck of the *Peter Iredale* with US senator Robert Kennedy and his wife, Ethel, in May 1968. Straub was busy protecting public access to Oregon beaches, so he and the citizens group Beaches Forever joined to create a measure authorizing a temporary gas tax to buy privately owned beach land. (Courtesy of Western Oregon University Archives, Robert W. Straub Collection.)

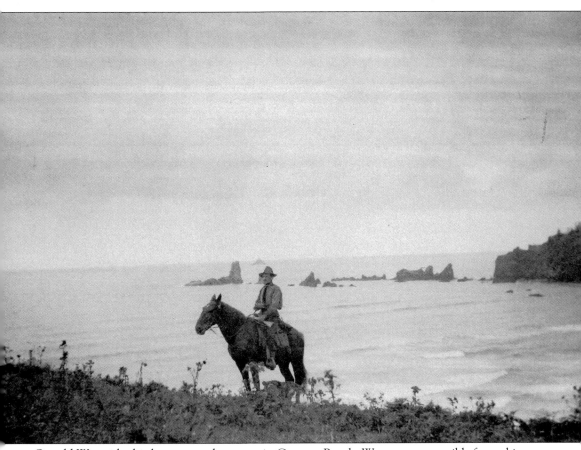

Oswald West rides his horse near the ocean in Cannon Beach. West was responsible for making the state's beaches public. In 1929, a person could still buy multiple acres and a house in Cannon Beach for under $5,000. In 1913, Senate Bill 22 was put forward by Gov. Oswald West because almost 25 miles of oceanfront property had already been sold on the north coast to private individuals, yet people still depended on beach access to travel. By blocking future sales of tidelands and protecting free passage, the bill also gave permanent right of access to more than 360 miles of shoreline for recreation. In 1967, Gov. Tom McCall supported the passage of the Oregon Beach Bill to continue West's concept of keeping Oregon's beaches open to the public. (Courtesy of Oregon Parks and Recreation Department.)

The Coaster Theatre Playhouse is seen from the courtyard looking toward Hemlock Street as it is today. From its early beginnings as the Coaster Roller Rink, built by Ray Walker and operating from 1920 to the 1950s, this historic site used to show silent movies with Miss Weeks accompanying on the piano. Folding chairs were placed on top of the rink for seating, and adults paid 15¢ and children paid 10¢. In 1972, the building was purchased by Maurie Clark, a Portland patron of the arts. Under his direction, a major remodel was undertaken, resulting in the building theater patrons see today. Portland State University Summer Stock Company became a regular performer each year, and other groups regularly presented concerts and performances throughout the season such as *The King and I*, *Auntie Mame*, *Fiddler on the Roof*, and *Lend Me a Tenor*. Coaster Theatre has presented scores of plays and musicals performed by hundreds of actors for thousands of appreciative patrons. (Courtesy of Coaster Theatre Playhouse.)

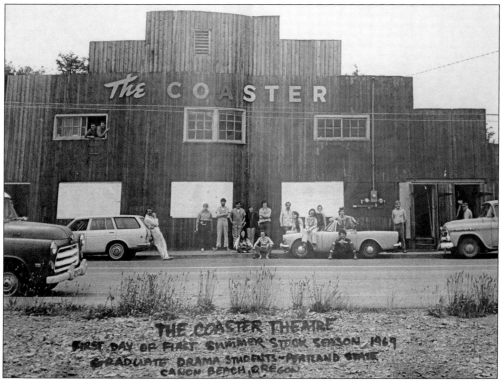

The Coaster Theatre, facing Hemlock Street, featured Portland State graduate drama students for the first summer stock. In the mid-1960s, Richard and Margaret Atherton bought the roller rink building with the dream of turning it into a theater. The transformation was a fulltime job, with over 55 townspeople working on the project. (Courtesy of Coaster Theatre Playhouse.)

This "after" photograph of the 1972 remodel shows the theater from the corner of Hemlock and First Streets. Designed by Ray Watkins and Bill Campbell, the beautifully redesigned theater opened on June 29, 1972, with the Portland State University Summer Stock Company. The Coaster Theatre serves as a regional resource and as the center for community activities for residents and guests of the northern Oregon coast. (Courtesy of Coaster Theatre Playhouse.)

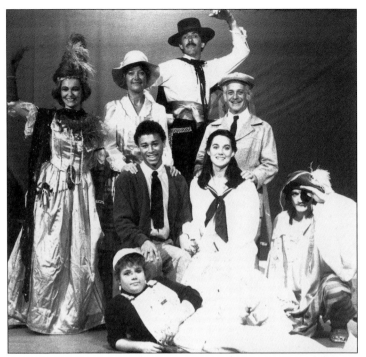

This cast photograph is from the 1984 production of *The Fantasticks*. The Coaster Theatre is currently a nonprofit organization dedicated to enhancing the cultural, artistic, and civic vitality of Cannon Beach by continuing the tradition of producing quality community theater and memorable experiences for residents and visitors of all ages. (Courtesy of Coaster Theatre Playhouse.)

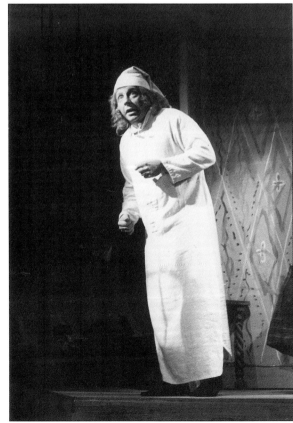

A scene from the 1993 production of *Scrooge* features Jerry Railton entertaining patrons in the title role. Upon Maurie Clark's death in 2001, Coaster Theatre Playhouse became a nonprofit organization. (Courtesy of Coaster Theatre Playhouse.)

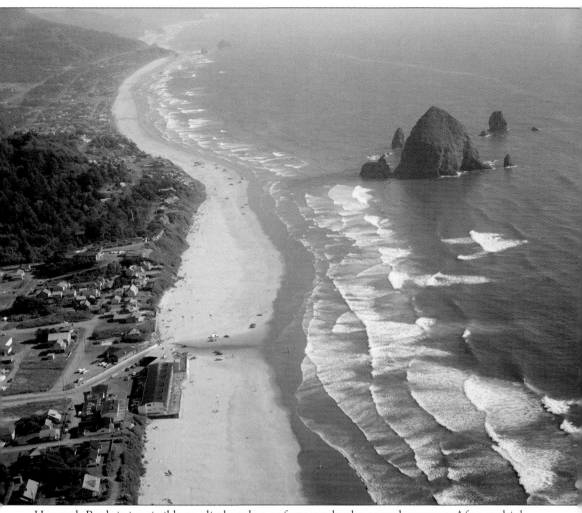

Haystack Rock is irresistible to climbers but unfortunately also very dangerous. After multiple rescue missions, officials finally decided to dynamite part of the rock in 1968 to prevent more accidents. Haystack Rock is one of the most photogenic icons in the state of Oregon. (Courtesy of Thomas Robinson, ackroyd C04842-6.)

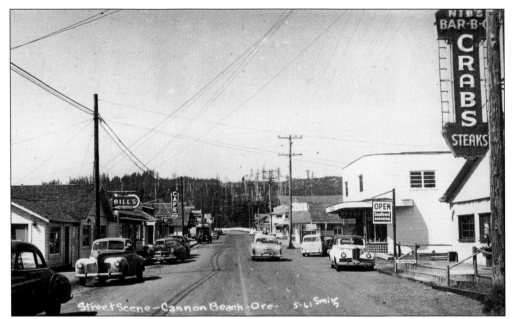

The main street in Cannon Beach, now Hemlock Street, is seen in 1946. Bill's Tavern, another restaurant, a drugstore, and Nib's BBQ can be identified on the strip. The town was still fairly undeveloped during this era and still had less than a couple hundred residents. Tourism had picked up, and businesses were doing fairly well. (Courtesy of Norm Gholston and Thomas Robinson, OPS-29-61.)

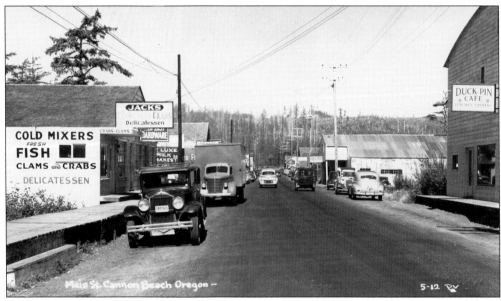

The main street is seen here around 1947. In the 1940s, places like the Duck Pin Café and Jack's Crabs & Deli served up lunch for locals and tourists alike. Stores such as Joe's Trading Post and a hardware store are also visible. This is also the site of the bowling alley that was built in 1945 by N.D. Jacobson. At another time, the building was called Duck Pin Bowling Alley and Penny Arcade. Children were paid to reset the bowling pins. (Courtesy of Norm Gholston and Thomas Robinson, 5-12 OPS-29-59.)

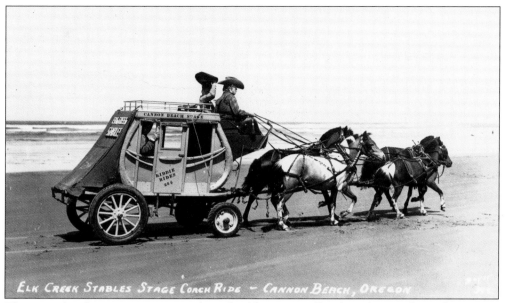

Three people ride in a cute carriage as four adorable ponies pull it along the coastline. The carriage reads "The Elk Creek Stables—Stage Coach Ride" and boasts "Kiddie Rides .25 cents!" Horses have always been a big part of Cannon Beach, from just plain transportation to helping with the mail routes to pulling automobiles from the surf. (Courtesy of Norm Gholston and Thomas Robinson, OPS-29-49.)

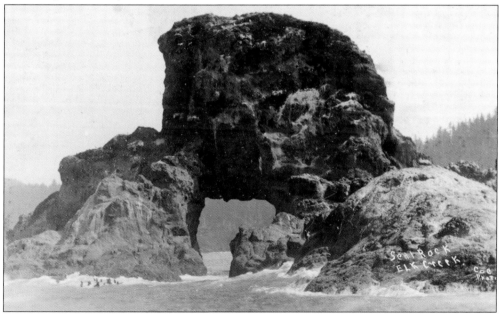

This beautiful photograph shows Seal Rock near Elk Creek in 1928. As stated by John M'Cormick, Elk Creek House proprietor, in an advertisement in the *Morning Oregonian* in 1902, "Elk Creek has advantages of mountain and sea beach combined. River and deep-sea fishing. Finest beach in the world. Hay Stack Rock. Tillamook Rock and Seal Rocks nearby. Good home cooking, plenty of sea food and quiet, healthful place for rest and recreation." (Courtesy of Norm Gholston and Thomas Robinson, OPS-29-55.)

53

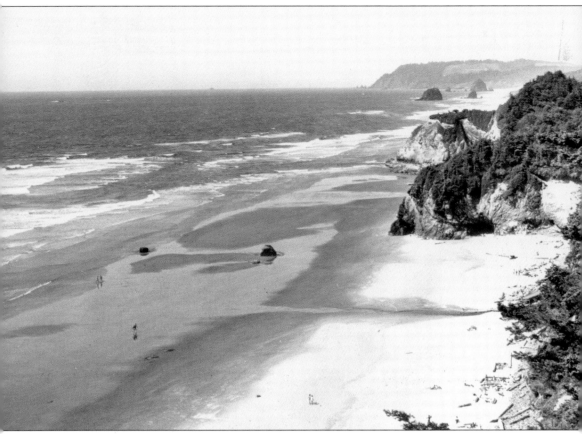

Jockey Cap Rock is seen here and Tolovana is north of that. The word Tolovana means "river of sticks." Mark Warren and his brother Will built the Warren Hotel and its very first guest was Oswald West, a friend of the Warrens. Alaska lovers, the Warren family mapped and surveyed all of Tolovana Park (see page 22), labeling all the streets after Native America–named rivers of Alaska. Tillamook Rock Lighthouse can be seen eerily in the distance from the shoreline. A local favorite, the historic Mo's Restaurant has the best clam chowder around. (Courtesy of Oregon Department of Transportation, So_CannonBeach0001.)

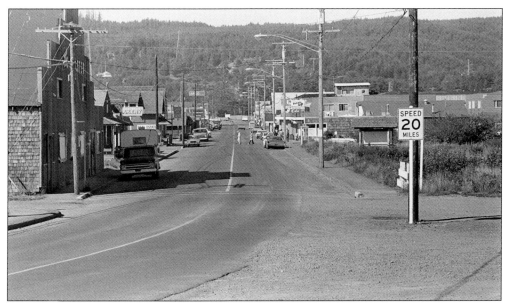

The main road in town, Hemlock Street, is pictured looking north in September 1971. On the left are Coaster Theatre, Cannon Beach Bakery, and Bill's Tavern. On the right is the Round Table Restaurant, built by Evie and Win Boothby in 1961. Rumor is that Boothby's sauerkraut custard pie even challenged Edna Osburn's famous blackberry pie. This restaurant boasted a 12-person round table that became the central gossip center. In 1946, the building was Joe's Trading Post, and later, the post office. (Courtesy of Thomas Robinson, falconer 0383J-09.)

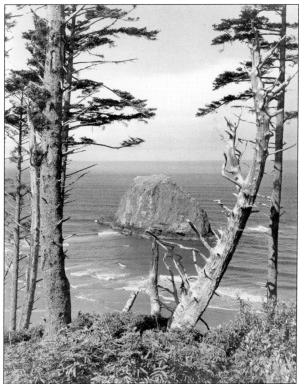

The Jockey Cap Rock is located near Silver Point at the south end of Tolovana. Silver Point was named after the silver-barked trees that used to grow there, but they have long since declined. The area was purchased from various owners between 1971 and 1985 and includes Humbug Point. After much debate, the area was developed for day use in the late 1970s. (Courtesy of Oregon Department of Transportation, JockeyCap0001.)

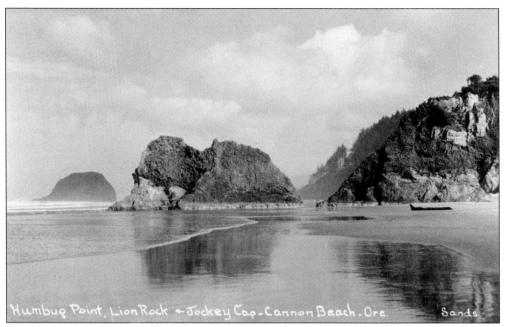

The gorgeous section of the beach known as Humbug Point is seen with Lion Rock and Jockey Cap Rock. The area now known as the Jockey Cap was purchased from various owners between 1971 and 1985. It includes forested Humbug Point on the ocean shore and attractive beach access. (Courtesy of Norm Gholston and Thomas Robinson, OPS-29-44.)

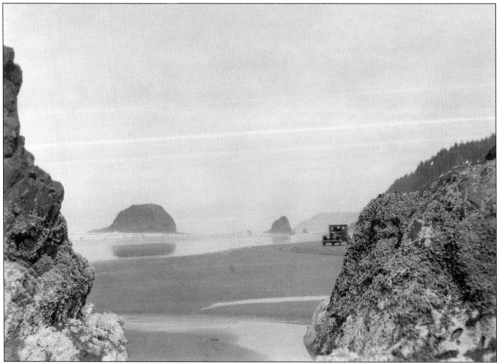

This photograph shows Jockey Cap with Haystack Rock in the distance. (Courtesy of Norm Gholston and Thomas Robinson, OPS-31-04.)

Three

ARCH CAPE, HUG POINT, AND MAKING THE ROADS

One of the greatest improvements to increasing traffic and tourism for Cannon Beach was the completion of the Arch Cape Tunnel in 1937. Previously, Highway 101 ran completely around Cannon Beach, passing inland to the Necanicum Junction, and then continued along what is now Highway 53 all the way down to Nehalem. When Highway 101 was rerouted to pass through Cannon Beach, continuing south to Arch Cape, the town became a wonderful little stop for people along the way. The Arch Cape Tunnel is 1,228 feet in length, 23 feet high, and 36 feet wide. Arch Cape, named for the rock arches found in the area, is a small community of less than 300 residents between Hug Point State Park to the north and Oswald West State Park to the south. Before the construction of roads, driving or walking along the actual coastline at Hug Point used to be the only way to proceed south. The precarious rock was only available for traffic during low tide and was still quite dangerous for stagecoaches, automobiles, horses, and foot travelers that would all have to share the narrow road. By hugging the edge of the cliff and escaping the waves of the Pacific Ocean, they could get to the other side. The original carved pedestrian hand and foot holds from 1893 and tire ruts can still be seen today. The rumor is that around 1920, a man from Arch Cape got his Maxwell motorcar stuck on the point during the incoming tide, and he got so angry he bought dynamite and blasted out the roadbed.

The road leading from Portland to the beach was also very significant in the creation of the coastal towns. Trying to get to the beach often took several long days when traveling by stagecoach or on horseback. Later, in automobiles, it still took seven or more hours from Portland to the coast on roads so winding that travelers soon became nauseous. When Sunset Highway (Highway 26, previously known as Wolf Creek Highway) was completed in 1950, it eliminated over 100 ridiculous curves, Cannon Beach became a short drive from Portland, just an hour and a half instead of an all-day ordeal.

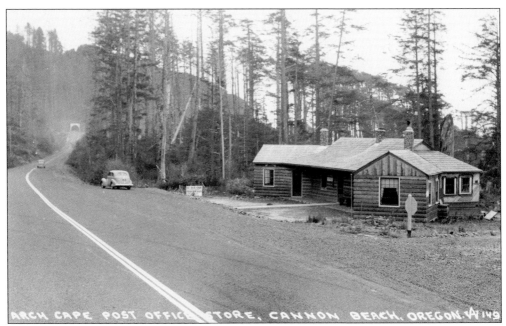

ARCH CAPE POST OFFICE STORE, CANNON BEACH, OREGON. 4149

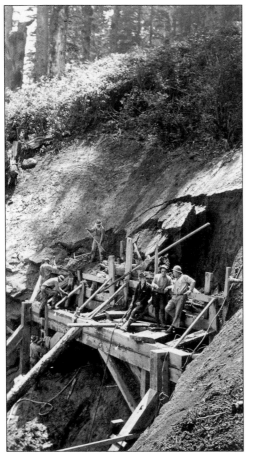

Pictured here is the Arch Cape Post Office in the 1940s, most likely 1942. The tunnel in Arch Cape was completed in 1940. A post office was established in Arch Cape in 1891. Mail was delivered once a week by a mail carrier on foot or horseback until around 1912, when train service was established. The building remains today, to the right heading south just before the tunnel. (Courtesy of Norm Gholston and Thomas Robinson, OPS-29-63.)

On February 25, 1936, the contract for the construction was issued, and by June 1936, the creation of the new Arch Cape Tunnel was well underway. Here, six men from the highway department are working hard setting the large beams. The nonstop rain caused extreme mud and turned a simple excavation into an absolute nightmare, causing multiple delays and increasing the costs. The dozer used was unable to operate under its own power for lack of traction and had to be dragged through using a gas donkey. Excavation of the 20,000 cubic yards of dirt at the south end of the tunnel also cost more than expected. (Courtesy of Oregon Department of Transportation, archcape0001.)

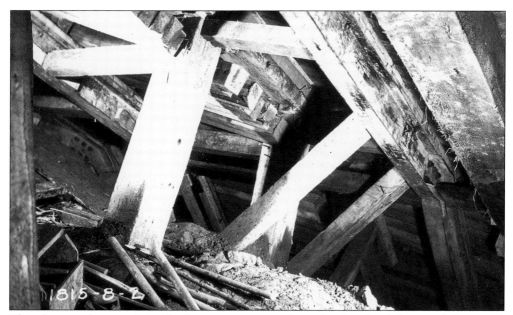

This close-up photograph inside the excavation site shows the detail and danger of the tunnel construction process, involving many timbers and sills to carry the load. On the south end, 358 feet of the tunnel had to be timbered due to the tremendous weight and movement of the land, which required more reinforcement. (Courtesy of Oregon Department of Transportation, archcape0006.)

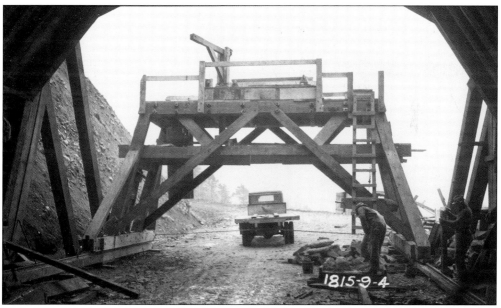

Two men are working on the tunnel excavating the land and rock. The construction of the tunnel was dreadfully slow due to the weather conditions, lack of proper equipment, and some problems with the crew. The equipment had to be replaced or changed out several times, and it took a long, frustrating month to place the north portal timbers. (Courtesy of Oregon Department of Transportation, archcape0008.)

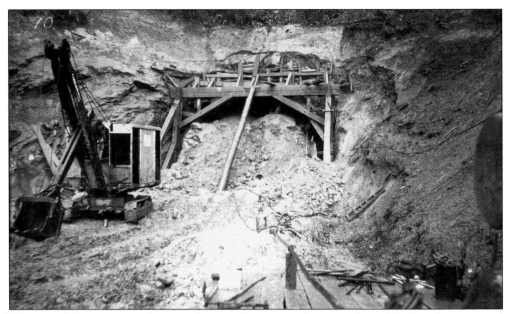

The recorded progress on the tunnel per work day was about two feet of timbered section and seven feet of rock section, which is considered slow. The tired crew had to work in extremely laborious and dangerous conditions with equipment that was not adequate for the job. Even so, they did a wonderful job, and the tunnel improved life in the nearby cities forever. (Courtesy of Oregon Department of Transportation, archcape0007.)

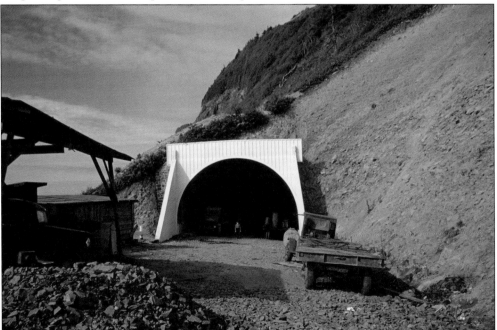

Paving of the Pacific Coast Highway at the Arch Cape Tunnel around 1940 was labor intensive. The extreme weight and slope of the mountain can be put into perspective in this photograph. To prevent dangerous movement during construction, the timbers had to be reinforced and grouted with a concrete mixture. (Courtesy of Thomas Robinson, CS00051-09.)

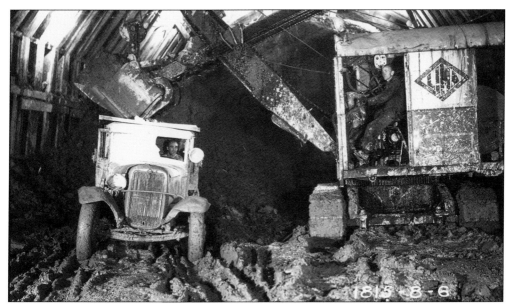

Two men are working inside the extremely dangerous conditions in the Arch Cape Tunnel in 1936. During the war, guards often patrolled the Arch Cape Tunnel by foot and on horseback. Cannon Beach wasn't the only town prepared for war. In Tillamook, the authorities had the Tillamook Rangers patrolling the beaches armed with shotguns and .22s. (Courtesy of Oregon Department of Transportation, archcape0005.)

A worker is pictured inside the Arch Cape Tunnel after it became damaged due to a speeding car crashing into the tunnel wall, triggering a collapse on April 23, 1959. (Courtesy of Thomas Robinson, deLay590423-04.)

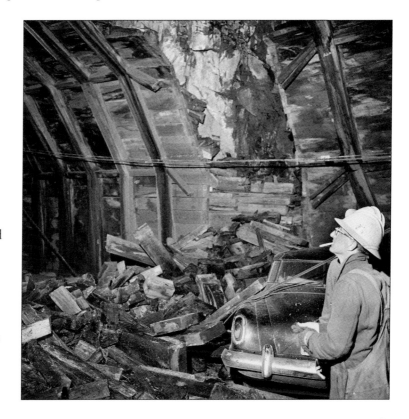

The long stretch of highway running from Portland toward Cannon Beach is now called Highway 26 or Sunset Highway, but in the 1930s, it was called Wolf Creek Highway. The hard work of laborers between 1933 and 1936 by both the WPA and the CCC during the Great Depression made the project possible. In 1949, the highway was finally completed. (Courtesy of Oregon Department of Transportation, WolfCreek0010.)

Highway 26 is almost 472 miles in length and connects US Route 101 on the Oregon coast near Cannon Beach with the Idaho state line east of Nyssa. (Courtesy of Oregon Department of Transportation, WolfCreek0003.)

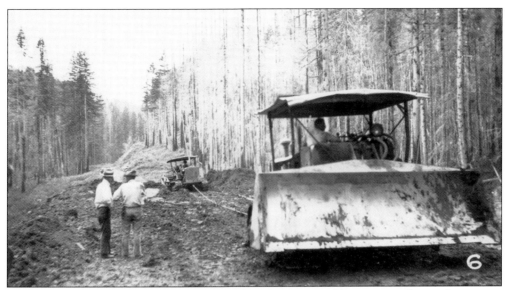

Four men, two driving the plow and bulldozer, the other two possibly engineers, discuss the progress of Highway 26 during its construction in 1936. The *Morning Oregonian* of January 1, 1921, wrote, "though what once was one of the worst roads in Oregon has been improved in the past couple years . . . no motorist need hesitate to make the tour." Little did they know that only 15 years later it would be improved even more. (Courtesy of Oregon Department of Transportation, 0005.)

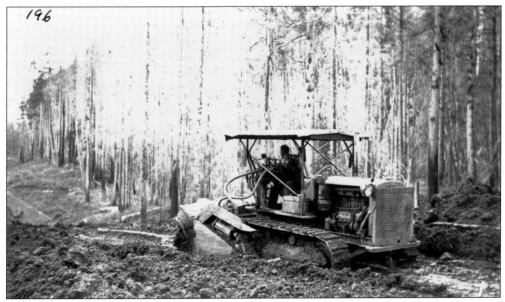

A worker pushes through the thick mud on his bulldozer in 1936 to create Highway 26, then known as Wolf Creek Highway. Between 1935 and 1943, the WPA offered eight million full-time jobs, and its goal was to provide one paid job for all families in which the breadwinner suffered long-term unemployment. (Courtesy of Oregon Department of Transportation, 0002.)

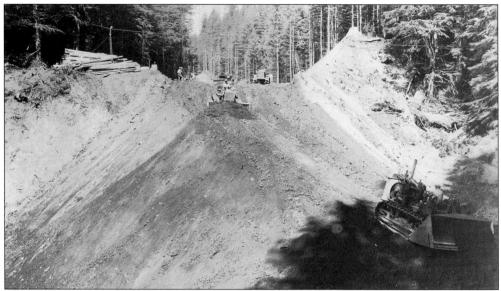

In 1934, several workers manage to somehow stay safe on their equipment even on an extremely steep slope stretching along Highway 26 in Clatsop County east of Cannon Beach. (Courtesy of Oregon Department of Transportation, 0007.)

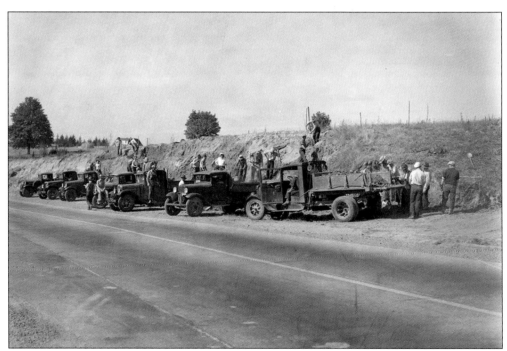

Many WPA workers take a short break to pose for a picture while working on Highway 26 on September 11, 1936. Prior to this, travelers heading to Cannon Beach from Astoria left by stagecoach in the early morning in order to get there by nightfall. (Courtesy of Oregon State Archives, 15812.)

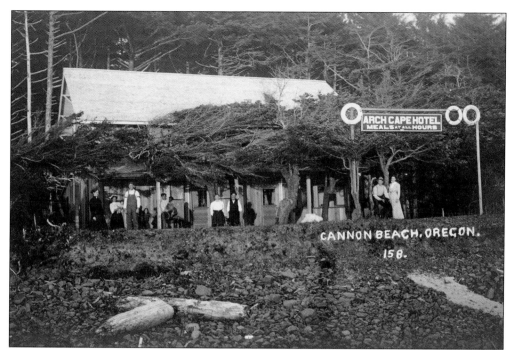

Arch Cape Hotel was purchased in 1929 by Elsie and Marie English, both school teachers. The sign reads "Meals at all Hours." They soon renamed it Singing Sands because of the sound the sand would make when people walked or ran on it. Back then, the hotel rates were $10–$15 per week or $2 per night. (Courtesy of Norm Gholston and Thomas Robinson, 158, OPS-29-31.)

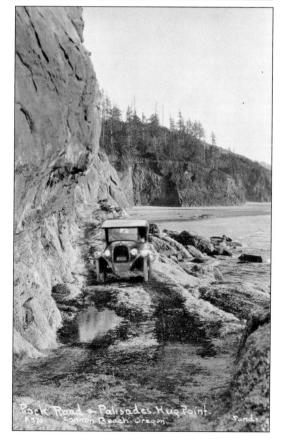

Before the highway was built, the rough and rocky road at Hug Point was the only way to travel along this stretch of the coast. The rock had carved stairs that led to the ledge at the top and were used by early travelers to negotiate the point when high tide prevented traveling around it. (Courtesy of Norm Gholston and Thomas Robinson, OPS-29-40.)

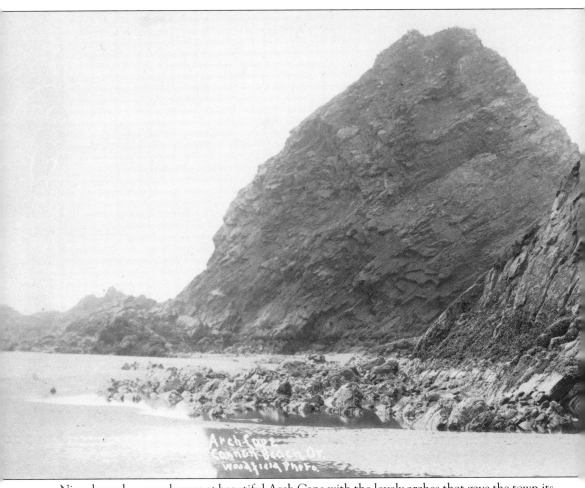

Nine dressed-up people pose at beautiful Arch Cape with the lovely arches that gave the town its name. A woman is wearing a Multnomah Athletic Club jacket, dating the photograph to around 1912. The automobile has 1912 Oregon license plate no. 8451. In February 2008, 162 years after

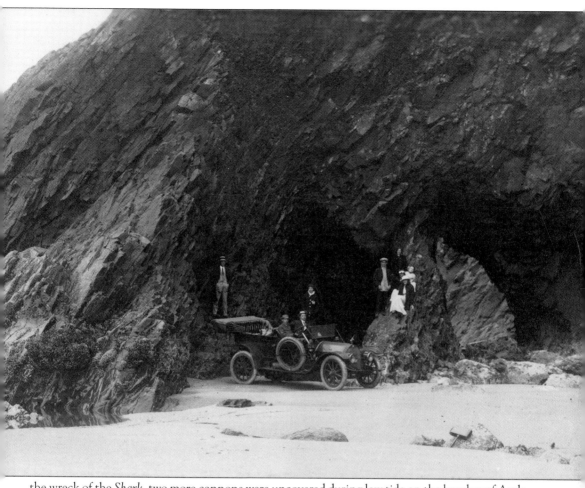

the wreck of the *Shark*, two more cannons were uncovered during low tide on the beaches of Arch Cape. Will more be found? (Courtesy of Norm Gholston and Thomas Robinson, OPS-29-37.)

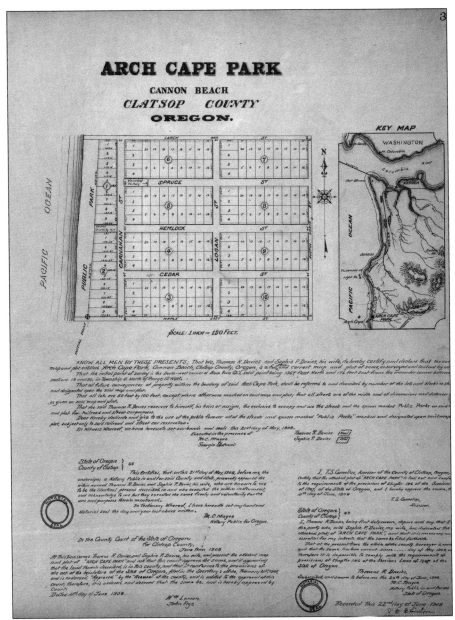

A plat of the Arch Cape area dated May 21, 1908, was submitted by Thomas and Sophie Davies. There were three other plats that covered more of the Arch Cape area: Cannon Beach Park, Cannon Beach Park as Extended, and Cannon Beach Park Extension. Like most places, Arch Cape was subdivided on multiple separate plats on multiple dates. All of these lots measured 50 by 100 feet, the same as the Cannon Beach lots. Notice that the middle street is named "Logan," probably after Frederick Herbert Logan, one of the original remittance men of the Cannon Beach area. On the right side, the street is called "Austin North Street," possibly in tribute to James Austin, a former Seaside postmaster who became obsessed with the idea of finding a cannon. He sold his hotel in Seaside and used the money to build a hotel and post office near Arch Cape. (Courtesy of Clatsop County Surveyor.)

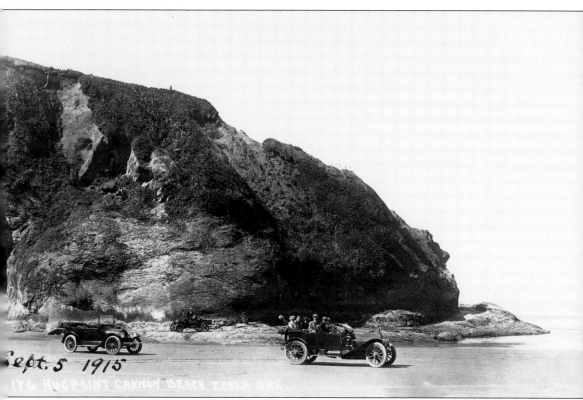

Automobiles, horses, and people all had to share the precarious narrow road at Hug Point. The original 1.3 acres of this tract were given to the state by Clatsop County in 1957. In 1968, land was purchased from Elizabeth Johnson that, added to a later exchange with Crown Zellerbach in 1978, netted 41 additional acres. Hug Point was so named because it was necessary to hug the rocks to get around the point on the ocean side without getting wet. The stamp on the back reads "Published by Pacific Photo Co., Salem Oregon." The date on the front is not the date of shooting. (Courtesy of Norm Gholston and Thomas Robinson, OPS-29-26.)

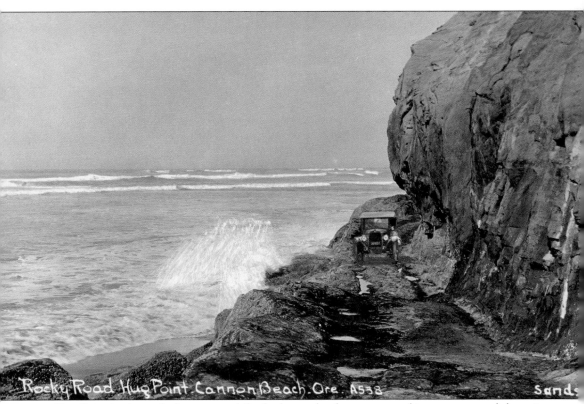

Rocky Road Hug Point. Cannon Beach. Ore. A533 Sands

Hug Point is pictured when automobiles had to make the nerve-wracking turn around the point to get to the other side. It was a fatiguing climb up and over the point until 1893, when hand and footholds were carved into the basalt and sandstone of the cliff. There are carved steps leading to the ledge at the top. (Courtesy of Norm Gholston and Thomas Robinson, OPS-29-27.)

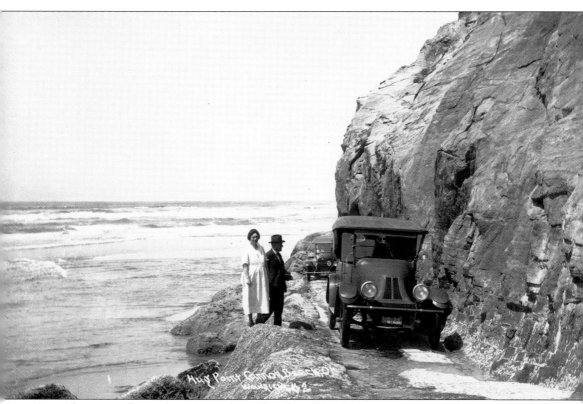

A very brave couple stands precariously on the edge of Hug Point as two cars pass by them to get to the other side of the point. The couple seems extremely calm, although the smiling woman's feet are just inches from the cliff. The cars have Oregon license plates dated 1923. (Courtesy of Norm Gholston and Thomas Robinson, Woodfield photo/OPS-29-28.)

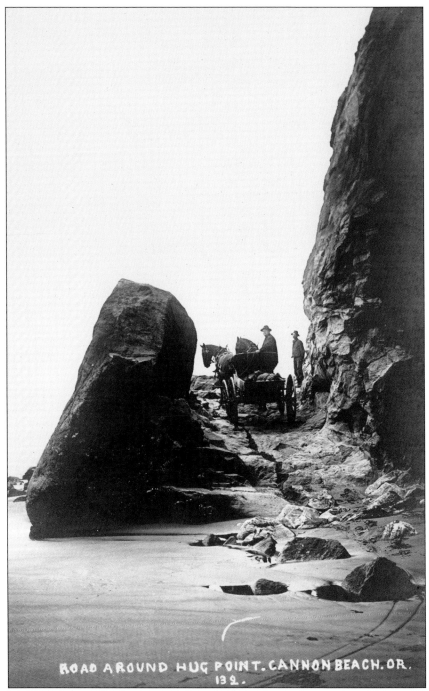

ROAD AROUND HUG POINT. CANNON BEACH. OR.
132.

Two men and their horses pull a carriage through the rocky road around Hug Point, though the wheels seem to struggle in the deep rut in the road. The area today is mostly houses and hotels. Just a little more than a century ago, people had to travel days to get a few miles and risk climbing around a rock face to reach the beach on the south side of Hug Point and eventually Arch Cape. The stamp on the back of this postcard reads "Photo by J. Waterhouse, Seaside, Oregon 132." (Courtesy of Norm Gholston and Thomas Robinson, OPS-29-29.)

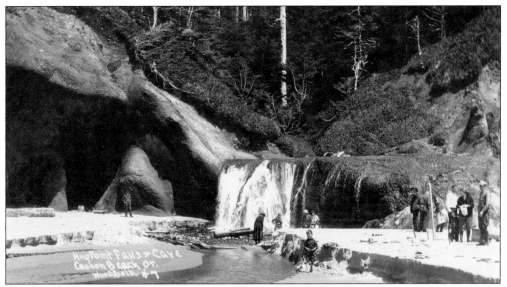

A group of water lovers splash in the waterfall by the cave at Hug Point in Arch Cape. Arch Cape was isolated by the natural barriers of the Tillamook Headland, Hug Point, the Arch Cape headland, and Neahkahnie Mountain. Early settlers used the beach as a highway, and in the 1910s, the roadbed around Hug Point was blasted out, which made the commute between Cannon Beach and Arch Cape easier. At that time, there was still no road to travel to and from Arch Cape. This postcard is postmarked July 17, 1928. (Courtesy of Norm Gholston and Thomas Robinson, OPS-29-32.)

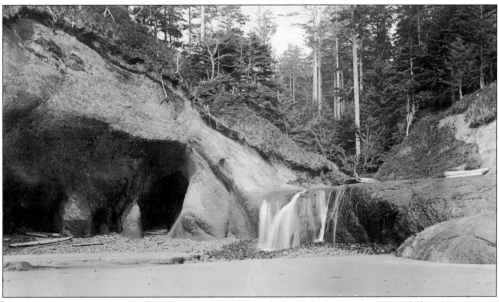

Over the years, beachgoers have always loved to splash and play in the waterfall at Hug Point. Highway 101 was completed in 1936, shortly before tunnel construction began. On February 6, 1936, a contract by the Oregon Highway Department authorized the construction of tunnels for .62 miles of highway roadbed, including 1,227 feet of tunnel 26 feet wide and 23 feet high. Note the lone man seated above the waterfall posing for the camera. (Courtesy of Norm Gholston and Thomas Robinson, 92 OPS-29-33.)

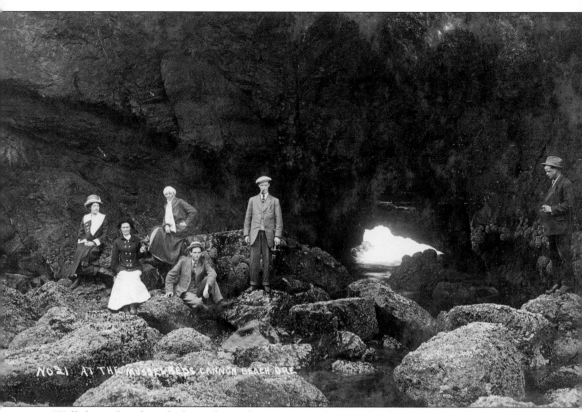

Well-dressed and ready for a photo shoot, six people pose for the camera at the mussel beds somewhere near Cannon Beach. The second woman from the left is holding up a five-pointed starfish. The once-prolific starfish are less common at the beach now due to what is known as "wilting disease." The men are wearing the same clothes as in the photograph at the top of page 26, which is dated 1912 by the auto's license plate. (Courtesy of Norm Gholston and Thomas Robinson, OPS-29-35.)

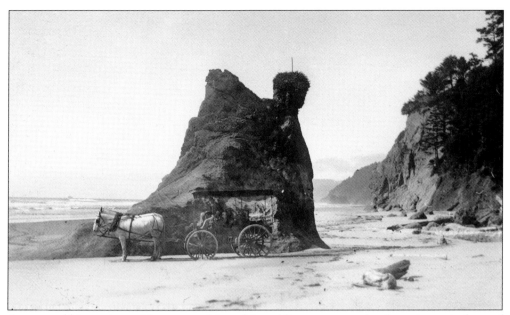

A man and his carriage with two matching white geldings stops to relax for a picture in front of what is labeled "Shoe Rock." Although this is a great beach picture, it is unknown exactly where Shoe Rock is. (Courtesy of Norm Gholston and Thomas Robinson, OPS-29-36.)

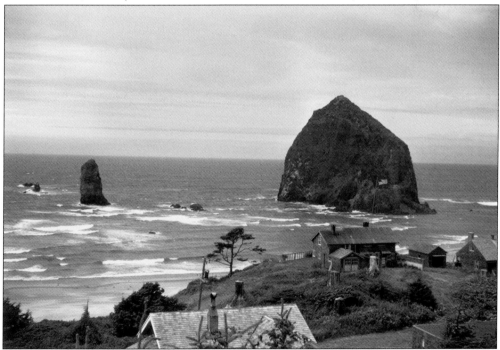

Haystack Rock is seen from the bluff in the early 1950s. During that time, parts of the Oregon coastline were still being used by automobile traffic. Even today, there are portions of the Oregon beaches are open to automobile traffic, and all of Oregon's coastal beaches are open to public access. Many lucky oceanfront homeowners enjoy unobstructed and breathtaking views of Haystack and the ocean from their homes. (Courtesy of Thomas Robinson, CS03642.)

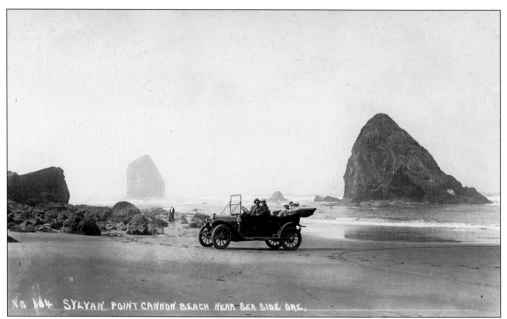

A family enjoys a drive on Sylvan Point in Cannon Beach near Seaside, Oregon. The area has also been called Sylvan Rock and Sylvan Point Rock. Many sections of the town have changed names over and over again until the town finally settled on "Cannon Beach." There are still many different sections of the beach today, such as Indian, Ecola, Crescent, Arcadia, and Silver Point. This postcard was published by Pacific Photo Co. of Salem, Oregon. (Courtesy of Norm Gholston and Thomas Robinson, OPS-29-42.)

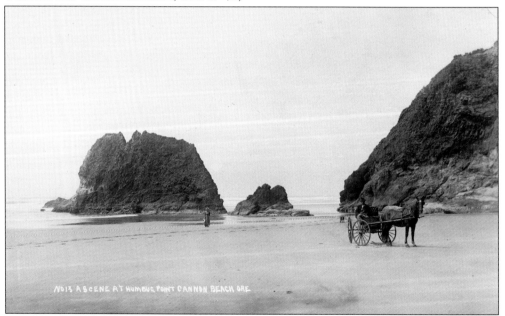

An unidentified couple enjoys the beach with their dog at Humbug Point. This area (now known as the Jockey Cap) was purchased from several people between 1971 and 1985, and after many discussions, meetings, and changes from the original plans, the area was developed for day use in the late 1970s. (Courtesy of Norm Gholston and Thomas Robinson, 13/OPS-29-43.)

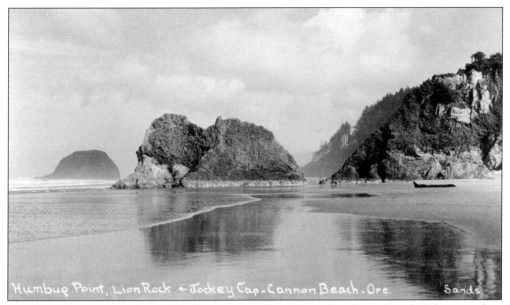

Whale watching is popular on the Oregon coast from December through early February, when the whales are on their annual 6,000-mile journey in the Pacific Ocean from the Arctic to the warm waters of Baja California. Then, from March through October, the whales return north with their calves. Here is Humbug Point, Lion Rock, and the Jockey Cap in Arch Cape. (Courtesy of Norm Gholston and Thomas Robinson, OPS-29-44.)

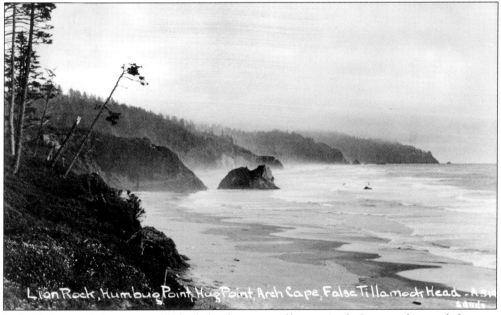

In 1891, James P. Austin established the first post office at Arch Cape and named the area "Cannon Beach," which reflected his hopes of finding the lost cannon. Austin knew that the cannon was supposedly buried in a creek bed nearby and reportedly spent much time and money trying to find the lost artifact. Pictured here are Lion Rock, Humbug Point, Hug Point, Arch Cape, and what some call False Tillamook Head. (Courtesy of Norm Gholston and Thomas Robinson, OPS-29-45.)

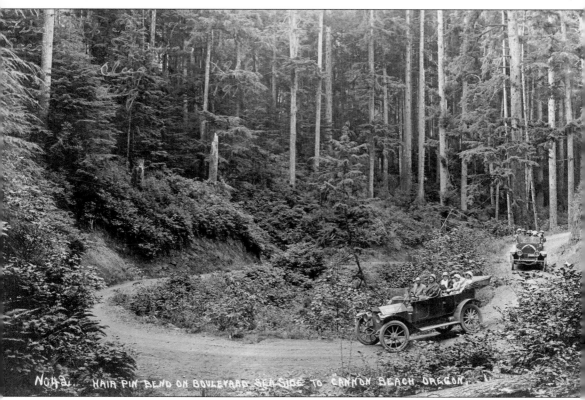

This postcard reads, "Hair Pin Bend on Boulevard, Seaside to Cannon Beach Oregon." It is hard to believe today that this is the same road, then called Elk Creek Road. Herbert Logan used his remittance money and partially funded the wagon road, which soon created an easier path for others to visit and possibly build cottages in this little beach town. In 1897, Logan filed for a license to sell liquor and decided to live permanently at Cannon Beach at his Elk Creek Hotel. (Courtesy of Norm Gholston and Thomas Robinson, OPS-29-46.)

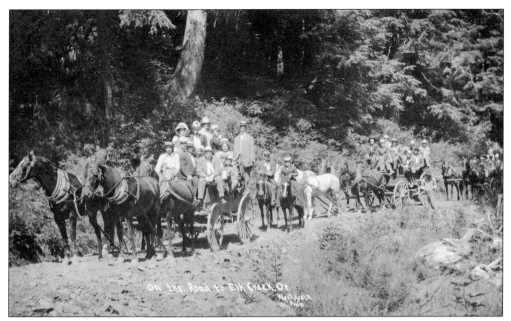

This large group of very well-dressed people eagerly traveled the Elk Creek Road on horseback, in carriages, and on foot. Several wear what look like ribbons pinned to their coats, possibly from being in a parade. Written on the back of the image is "Dad-rear seat—second carriage." (Courtesy of Norm Gholston and Thomas Robinson, OPS-29-50.)

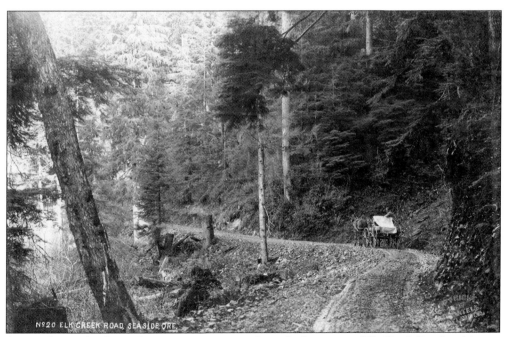

A man driving his horse-drawn carriage passes through the trees on Elk Creek Road on his way either to or from Seaside. The road seems fairly dry, although ruts can still be seen. The embossed card reads, "Elk Creek Road, Seaside Ore" and is postmarked November 1908. (Courtesy of Norm Gholston and Thomas Robinson, OPS-29-51.)

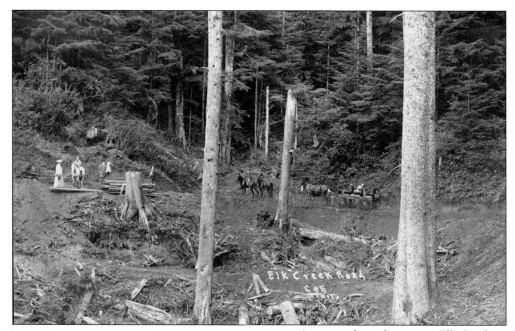

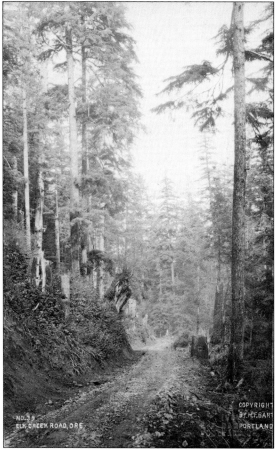

A group of people pose on Elk Creek Road. The horseback rider in the center, leading a second, riderless horse, might be Joe Walsh. Some excavation and timber felling is taking place to clear more land, and a young couple carefully watches their little girl as she stands on the pile of boards. The woman in the carriage at right seems to be holding a baby wrapped in a white blanket. The card reads, "Elk Creek Road. Coe photo." (Courtesy of Norm Gholston and Thomas Robinson, OPS-29-52.)

Another great photograph of Elk Creek Road shows what look like big chunks of rock or gravel to help control the mud. Since there was no real road leading from Seaside to Cannon Beach, Herbert Logan and other investors used their own money to finance the construction of the Old Elk Creek Road in 1907. This treacherous path had many nerve-racking curves that a carriage driver had to maneuver. There was a toll charged even though the road was a muddy mess most of the year. (Courtesy of Norm Gholston and Thomas Robinson, OPS-29-53.)

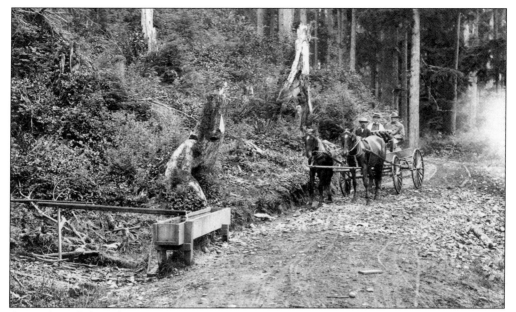

A couple and their driver casually make their way along Elk Creek Road. The roadside horse trough utilizing fresh spring water from the hillside is a great touch. Once visitors arrived, they would often stay the whole summer and thus became part of the community. There were a variety of reasons for these long-term stays, but one of the most important was that before the time of automobiles, it took a lot of time to reach the coast. Penciled on the back of this image is "Elk Creek Rd." (Courtesy of Norm Gholston and Thomas Robinson, OPS-29-54.)

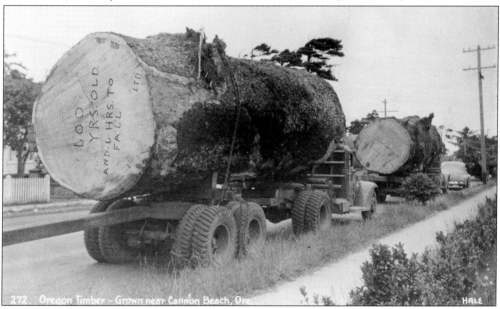

It seems a shame to cut down such old-growth timber as this. The tree has writing on it that states; "600 years old . . . And 6 hours to fall." Some of the finest and largest Sitka spruce trees in the world, with 12 to 20 growth rings per inch, were harvested from forests adjacent to Cannon Beach. The trees that were not used to build homes were usually cut down and burned to make way for future development. (Courtesy of Norm Gholston and Thomas Robinson, OPS-29-48.)

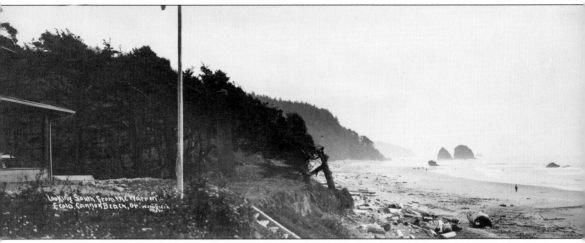

This gorgeous view looks south from the front lawn area at the Warren Hotel at Ecola. The flagpole is visible, and several people are beachcombing for shells. (Courtesy of Norm Gholston and Thomas Robinson, OPS-29-65.)

Four

ECOLA STATE PARK AND "TERRIBLE TILLY"

The original 450 acres of Ecola State Park were deeded to the Oregon State Parks Department on February 11, 1932. Most of the land was donated by several of Cannon Beach's most well-known families, including the Glisans, Minotts, and Flanderses. Then, 229 acres were purchased by the state from Allen Lewis for just $17,500. Many people disagreed about spending money to build a large state park during the horrible economic times of the Great Depression. However, Oregon State Parks superintendent Samuel Boardman strongly supported the project and thought it was a great idea. Later, more land was purchased from Crown Zellerbach Corporation for $46,063 after being logged, and the World War II Army radar station tract on Tillamook Head was acquired as well. Ecola State Park was developed by the CCC under the advice of the National Park Service beginning in 1934. Constructing the park created many jobs and helped some families through the Depression. The corps worked to improve roadways, build new water systems, construct picnic and barbecue areas, and lay stonework that is still there today. In exchange for their labor, the men received room and board and a decent wage. Ecola State Park was completed in 1936, taking just under two years to finish. Improvements included paved roads, picnic areas, walking trails, the office, a workshop, and a caretaker's house.

Some of the shallow soils on steep slopes at Ecola Park are subject to rapid erosion following heavy rains. In 1961, a landslide at Ecola Point damaged 125 acres and caused the park to be closed for 10 months. Today, the park is a very important part of Cannon Beach, and countless visitors enjoy its beauty. Cannon Beach has several other small parks: Les Shirley, Ecola Creek, Whale, City, Elk Run, Madison, and Tolovana Wayside Parks.

The creation of the Tillamook Rock Lighthouse in 1879 was much needed, but it was an extremely expensive and dangerous project. Surveyors and workers had to access the rock by carefully getting out of a rocking boat and jumping onto it. An unfortunate disaster happened when the master mason, John Trewavas, and his assistant, Cherry, struggled to land on the rock. Trewavas slipped and fell into the freezing sea. Cherry dove in to try to rescue him, but Trewavas's body was never found. After several other tragedies, the lighthouse soon earned the nickname "Terrible Tilly" and was said to be haunted by ghosts and a phantom ship. Tilly was lit on January 21, 1881, and its beam showed 133 feet above the ocean, flashing every five seconds. In 1957, Tilly was shut down and replaced by a whistle buoy; in 1981, it was listed in the National Register of historic Places.

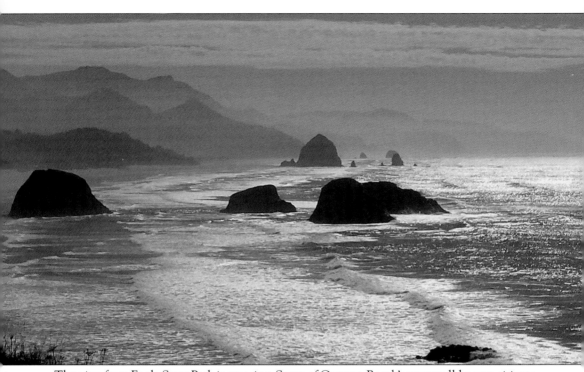

The view from Ecola State Park is amazing. Some of Cannon Beach's most well-known citizens—Rodney L. Glisan, Florence G. Minott, and Caroline and Louise Flanders—originally owned 49 percent of the 450 acres of Ecola State Park. Many huge trees were cut down in order to make way for the new park. Work didn't end with the CCC camp's closure in 1936. In 1948, Samuel Boardman was instrumental in purchasing an additional 308 acres, bringing the park to more than 1,300 acres of forest, beaches, and offshore roads. Boardman was instrumental in developing Short Sand Beach, Cape Meares, Cape Lookout, and Saddle Mountain Parks, but Ecola State Park was his personal favorite. (Author's collection.)

In 1806, Capt. William Clark and 12 other members of the Corps of Discovery traveled through what is now Ecola State Park in search of a beached whale. The team needed the blubber and wanted to trade. After reaching the north slope of Tillamook Head, Clark grabbed his journal and described the area as "the grandest and most pleasing prospects which my eyes ever surveyed . . . which gives this Coast a most romantic appearance." (Author's collection.)

The park's wonderful trails include an eight-mile segment of the Oregon Coast Trail, and a two-and-a-half-mile historical interpretive route called the Clatsop Loop Trail. A gorgeous, secluded section of coastline called Indian Beach is a favorite of surfers and beachcombers alike, offering interesting tide pools. (Author's collection.)

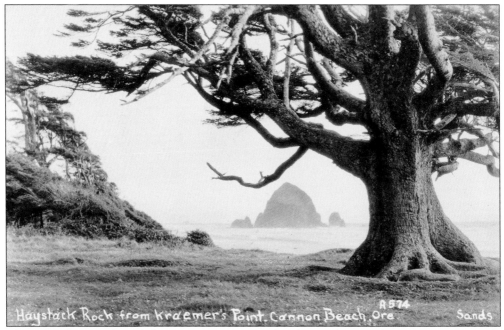

This view of Haystack Rock from Kraemer's Point is dated around 1930. The area, also commonly spelled "Kramer Point," is the point where Ecola Creek empties into the Pacific Ocean. (Courtesy of Norm Gholston and Thomas Robinson, OPS-29-09.)

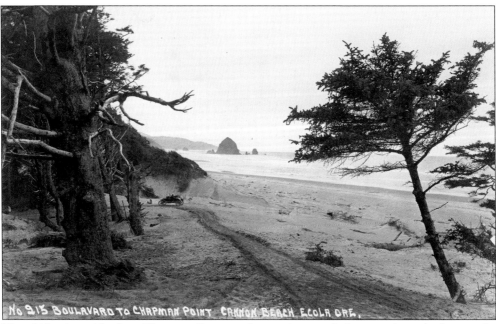

The old boulevard leads to Chapman Point on the northern end of town, where the large rocks (locally called the Bird Rocks) are the home to birds known as common murres, a black-and-white penguin-like species that nests there. (Courtesy of Norm Gholston and Thomas Robinson, 215. OPS-29-08.)

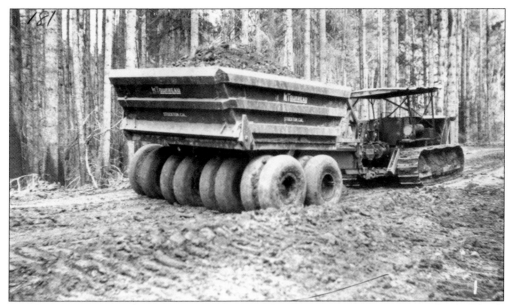

This huge vehicle was used by the Oregon Road and Transportation Department to haul off loads of debris and dirt while building Wolf Creek Highway in the 1930s. Wolf Creek Highway is now called Highway 26 (or Sunset Highway) and runs from Portland to the beach. This load includes 50 tons of debris and dirt. (Courtesy of Oregon Department of Transportation.)

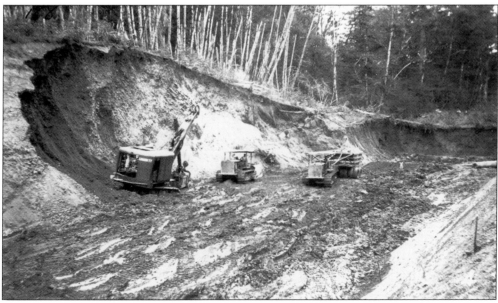

This photograph of Wolf Creek Highway around 1936 shows that large amounts of land sometimes needed to be removed in order to build a highway. It was a very dangerous and time-consuming job. Constructing what is now Highway 26, the bloodline to the coast from Portland, took many years and thousands of hours of labor. (Courtesy of Oregon Department of Transportation.)

The Oregon coastline is one of the most spectacular places to visit. It boasts miles of clean, sandy shores and dozens of rock formations that house various birds. The adorable tufted puffins are a local favorite with their bright orange beaks, white mask on their faces, and golden plume feathers. Seagulls soar casually along the ocean's breeze, their comforting caw symbolic of being at the beach. The tide pools are home to many species of marine life—starfish, tiny minnows, clams, mussels, purple and orange starfish, and green anemones just to name a few. Common murres make nests on any rock formation that is available to them. During certain months, almost 20,000 35-ton gray whales migrate through and can be seen offshore. Other times, herds of Roosevelt elk can be seen walking lazily along paths near the park, grazing on the grass in the meadows. Below, a family enjoys the beach in 1969. (Both, author's collection.)

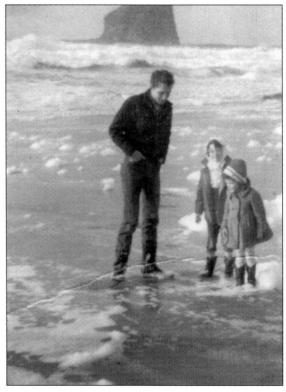

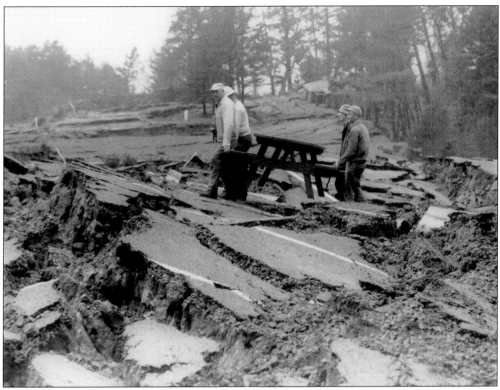

Years after becoming the state park people came to love and know, Ecola experienced what was called "earth slippage." This unfortunate landslide removed parking areas and parts of the roadways and even damaged stone buildings that once occupied the upper portion of the park. The slippage occurred in March 1961 and caused the park to be closed for a period of time. These four workers carry off a picnic table. (Courtesy of Oregon Parks and Recreation Department, Oregon State Archives.)

Here a building is being destroyed by the slippage at Ecola State Park in 1961, as well as a partially crushed car to the right. Due to this slide, many safety precautions were set in place to keep the park from sliding in the future. The park was repaired and today safely receives almost 600,000 visitors a year. (Courtesy of Oregon Parks and Recreation Department, Oregon State Archives.)

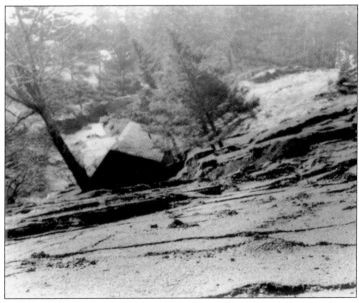

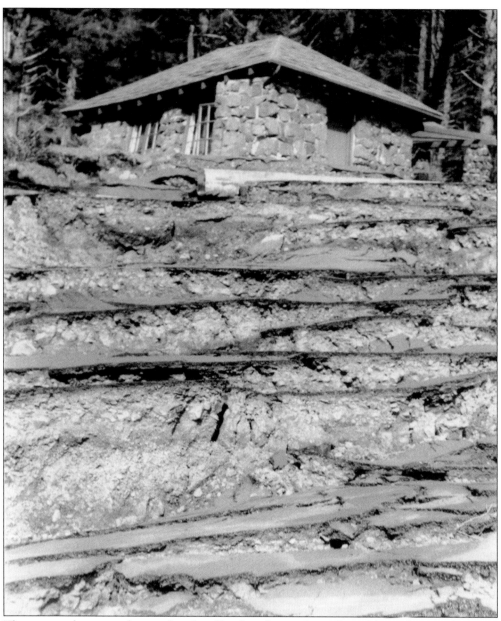

The extreme damage to the paved road and land can be seen here. One of the park's stone buildings was on the brink of total destruction as the roadway dropped by several feet. The damage covered half a mile and 125 acres and advanced at the rate of three feet per day for about two weeks. The vertical displacement of the land varied from 40 feet to upwards of 200 feet in places. The state Department of Geology and Mineral Industries reported in 1961, "Landslides in Ecola State Park are essentially the result of over-steepening of unstable rocks in the sea cliffs by wave erosion. Stable volcanic rocks resist erosion and form nearly vertical headlands such as Tillamook Head, Ecola Point, and Chapman Point. But less competent sedimentary rocks, when undermined by wave erosion and further weakened by water saturation during the winter months, begin moving seaward under the force of gravity." (Courtesy of Oregon Parks and Recreation Department, Oregon State Archives.)

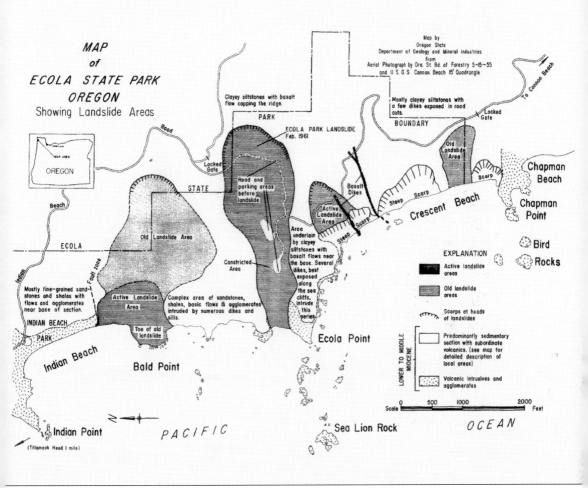

The following labels appear on the map:

MAP
of
ECOLA STATE PARK
OREGON
Showing Landslide Areas

Map by
Oregon State
Department of Geology and Mineral Industries
from
Aerial Photograph by Ore. St. Bd. of Forestry 5-15-55
and U. S. G. S. Cannon Beach 15' Quadrangle

OREGON
MAP AREA

Clayey siltstones with basalt flow capping the ridge.

Mostly clayey siltstones with a few dikes exposed in road cuts.

PARK
BOUNDARY

ECOLA PARK LANDSLIDE
Feb. 1961

To Cannon Beach

Road
Locked Gate

STATE

Road and parking areas before landslide

Basalt Dikes

Old Landslide Area

Locked Gate

Chapman Beach

Chapman Point

Beach

ECOLA

Old Landslide Area

Active Landslide Area

Area underlain by clayey siltstones with basalt flows near the base. Several dikes, best exposed along the sea cliffs, intrude this series.

Steep Scarp

Steep Scarp

Crescent Beach

Scarp

Bird Rocks

EXPLANATION

Mostly fine-grained sandstones and shales with flows and agglomerates near base of section.

Constricted Area

Active Landslide Area

Complex area of sandstones, shales, basic flows & agglomerates intruded by numerous dikes and sills.

INDIAN BEACH

PARK

Toe of old landslide

Indian Beach

Bald Point

Ecola Point

Active landslide areas

Old landslide areas

Scarps at heads of landslides

Predominantly sedimentary section with subordinate volcanics. (see map for detailed description of local areas)

Volcanic intrusives and agglomerates

LOWER TO MIDDLE MIOCENE

0 500 1000 2000
Scale Feet

N

Indian Point
(Tillamook Head 1 mile)

PACIFIC Sea Lion Rock OCEAN

This hand-drawn map from 1961 shows the various areas of damage at Ecola State Park after the slippage incident. It also indicates the locales of several nearby beaches and points—Indian Point and Beach, Bald Point, Ecola Point, Crescent Beach, Chapman Point and Beach, and Bird and Sea Lion Rocks. The final slippage report from the Oregon State Department of Geology and Mineral Industries in 1961 reads, "Ecola State Park is underlain by marine sediments and volcanic rocks of the Tertiary age. . . . Oregon, because of its rugged coastal topography, possesses one of the most scenic shorelines in the country, and many places along it make excellent home sites and recreation areas. Unfortunately, some of these localities, as exemplified by Ecola Park, are susceptible to land sliding through erosion by strong waves. . . . The Oregon coast is undergoing vigorous attack by the sea, and anyone who has visited the beaches during a storm can appreciate the energy expended by wave action. At the Tillamook Rock Lighthouse near Tillamook Head, waves have more than once broken the plate glass of the light 132 feet above sea level." (Courtesy of Oregon State Department of Geology and Mineral Industries.)

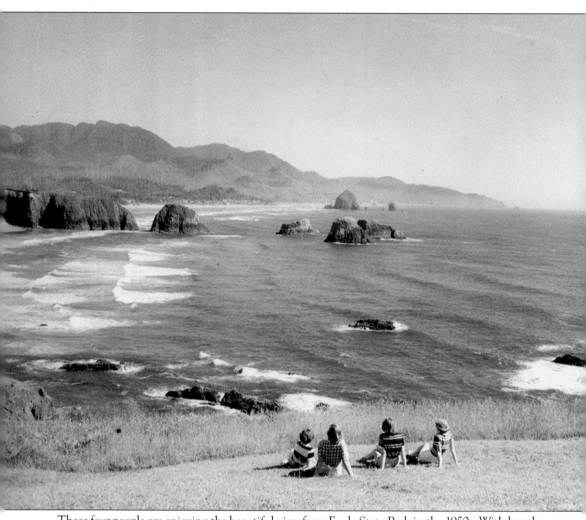

These four people are enjoying the beautiful view from Ecola State Park in the 1950s. With less than 125 people residing in Cannon Beach at that time, the town was still a private piece of paradise. Ecola Park contains examples of old growth Sitka spruce and western hemlock trees that provide an irresistible home for elk, deer, and other wildlife. The large Sitka spruce trees were heavily logged during World Wars I and II to make American and British airplane frames and propellers. Hemlock trees can grow longer and tower higher than other surrounding trees. In Ecola State Park, a national recreation trail was dedicated in April 1972 and is called the Tillamook Head Trail. It runs six miles from Seaside down to Cannon Beach. Tillamook Head is a high point on the trail between Seaside and Indian Beach. (Courtesy of Oregon State Archives, 547182.)

Large sections of land in Tillamook County heading toward Cannon Beach and Ecola State Park had to be cleared. At the time, donkey engines were used to pile up the debris and stumps that were to be burned later. Here, an obviously fearless man is sitting on top of a cable wire strung between the trees. He may have been the one in charge of unhooking the logs after they were carried up to the pile. He does not seem to be wearing a harness or any safety equipment. This photograph was taken sometime between 1890 and 1920. (Courtesy of Oregon State Archives, 885125.)

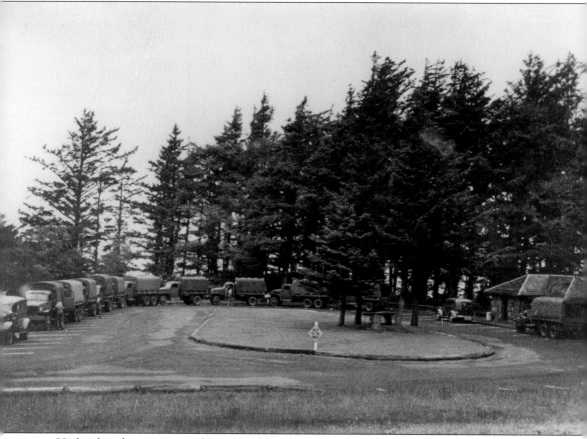

Under the administration of Pres. Franklin Roosevelt, the job of constructing Ecola State Park fell to the men in the CCC, and the park took two years to complete, from 1934 to 1936. Here, a line of trucks are parked at the park's entrance. In 1932, the first land acquired for the park was 451 acres from Ecola Point and Indian Beach Corporation. Following this, Rodney Glisan, Florence Minott, and Caroline and Louise Flanders all donated their one-half interest in the property. The land for a trail over Tillamook Head was donated by Ida Fleming (seven acres), the Angora Club of Astoria (15 acres), and A.W. Kendall (two acres). In 1942, 109 acres were attained from the government land office for $1.25 per acre. (Courtesy of Oregon Parks and Recreation Department, Oregon State Archives, 10274266.)

Several families are enjoying a sunny day at Ecola State Park in 1947. In the early 1950s, a campground was developed in the wave of enthusiasm that followed the end of World War II, but the camp was abandoned by 1954. (Courtesy of Oregon Parks and Recreation Department, Oregon State Archives.)

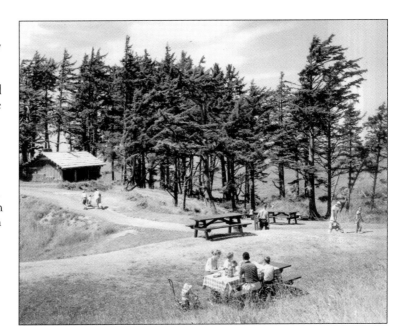

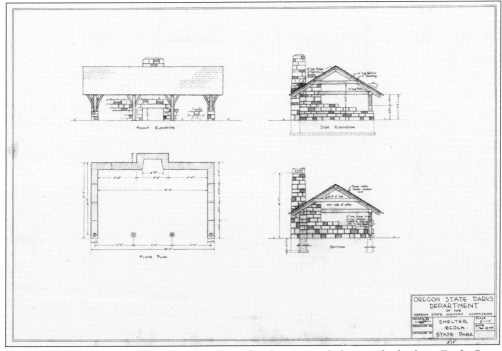

This is a hand drawing done by an engineer for the picnic shelters to be built in Ecola State Park's picnic area in 1947. The initial job of constructing the park had fallen to the CCC, and they received room, board, and a livable wage. Over three million CCC workers helped build roads, picnic areas, and other public service buildings. (Courtesy of Oregon Parks and Recreation Department, Oregon State Archives.)

A family with two small children overlooks the ocean from Ecola State Park to view Tillamook Rock Lighthouse, just over a mile off Oregon's rocky shores in the distance. The Columbia River has long been busy with maritime activity, and the waters surrounding it are considered some of the most dangerous in the world. (Courtesy of Oregon Parks and Recreation Department, Oregon State Archives.)

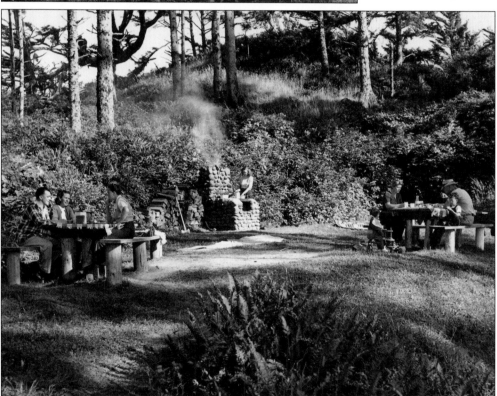

The picnic shelters at Ecola State Park provided countless hours of fun and a convenient place to barbecue for everyone. Here, two families are sitting at picnic tables enjoying the cool ocean breeze and sunshine. The CCC worked to improve roadways, build water systems, construct picnic areas, and lay stonework that is still there today. (Courtesy of Oregon Parks and Recreation Department, Oregon State Archives.)

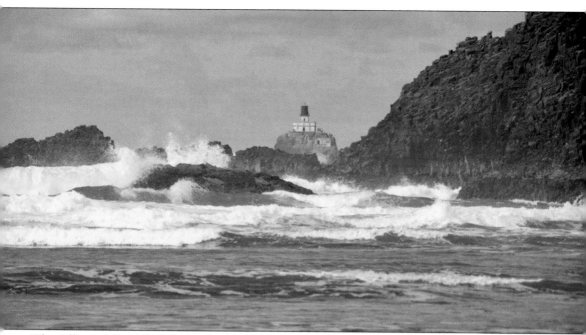

The Tillamook Rock Lighthouse, built in 1879 and in operation from 1881 to 1957, is an amazing display of engineering and hard work. Considered one of the most expensive lighthouses to build, its frightening setting has claimed several lives. At the time, some hoped that a lighthouse would be built on Tillamook Head instead, about 20 miles south of the Columbia River. Even just getting supplies to the lighthouse was a dangerous act, as items had to be pulled back and forth on ropes from a rocking boat. Men hired to work on its construction were often kept away from the locals so they couldn't hear the gossip about it being haunted and unlucky. The cliffs are steep and go deep into the ocean to depths of 96 to 240 feet. The first crew of workers became stranded by high winds and fierce waves and, since no boat could approach the rock to help them, they were attacked by sea lions and suffered extreme cold. The lighthouse project took 575 days to complete. Brave lighthouse keepers were carefully hoisted to the rock by a derrick and breeches buoy. In 1934, the Fresnel lens was crushed by a violent storm. In 1980, Tilly was converted into a private columbarium housing about 30 lonely urns. (Courtesy of Oregon Parks and Recreation Department, Oregon State Archives.)

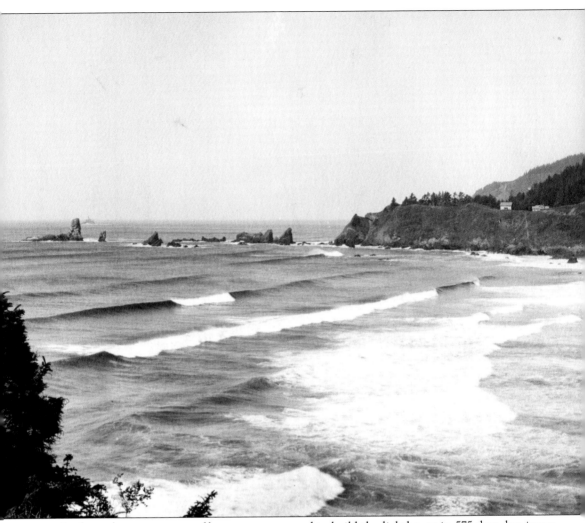

In the early years, a team of brave men managed to build the lighthouse in 575 days, but it was exhausting and frightening—they had to rig a line between their boat and the top of the rock to hoist both their tools and themselves back and forth. Just before the lighthouse finally opened, a ship called the *Lupatia*, sailing during a thick fog, came way too close to the shore and met its dreadful fate. The next morning, the bodies of all 16 crewmembers had washed up on the rock (visible here in the distance). (Courtesy of Thomas Robinson, OPS-31-001.)

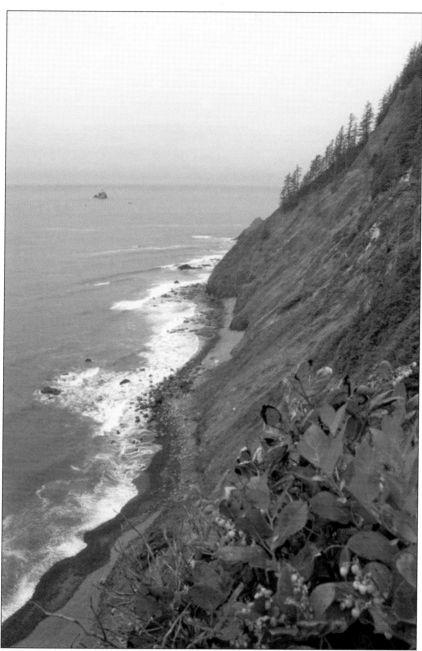

The steep cliffs near Ecola State Park are in the foreground of this image of Tillamook Rock Lighthouse in the distance. The construction crew consisted of four men at a time, who were under constant stress with the severe isolation, the sound of the crashing waves, and loud foghorns ringing in their ears. Edgy nerves and squabbles were typical complaints among the team. A few reports of men wanting to kill each other surfaced now and then. The Tillamook Rock Lighthouse served the Northwest for 77 years until it was replaced in 1957 with a whistle buoy. In 1980, a woman named Mimi Morissette bought the lighthouse with a group of investors for $50,000 and began promoting it as a columbarium. (Courtesy of Oregon Parks and Recreation Department, Oregon State Archives, ecola104142.)

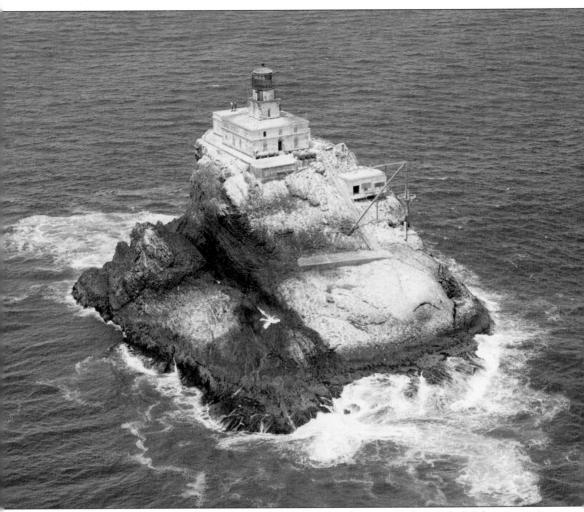

The 80-by-45-foot building was designed to house four keepers, with a 32-by-28-foot extension for the fog signal equipment. The 16-foot square tower rising from the center of the building supports the lantern room and parapet, which had a Fresnel lens. The light shone 133 feet above sea level and flashed every five seconds. The cost to build it was $125,000—equivalent to just over $3 million today—making it the most expensive West Coast lighthouse ever built. It is pictured here on May 27, 1975. (Courtesy of Thomas Robinson, ackroyd_C03867-6.)

Five

FROM THE ARCHIVES

There are always fascinating photographs in the dusty old archives and people's closets that history junkies find amazing. They might not fit into any particular chapter, or arrive a little too late during the process, but are just too wonderful not to include! In this chapter is a great collection from the archives that any lover of history—and more so a lover of Cannon Beach—will be thankful was included.

The "Oregon Pony," as it was called, was the first small steam locomotive used in 1862 by the Portage Railroad at the Cascades of the Columbia. The sign on the side reads: "The first locomotive on the Pacific Coast . . . Donated to the Oregon Historical Society in trust for the State of Oregon by David Hews of San Francisco, CA." When railroad lines were finally finished between Astoria and Seaside in the late 1890s, development expanded in this area, then known as Elk Creek. After the turn of the 20th century, the area south of the creek was divided into small lots that sold for $100 each. In the 1930s, with the completion of Highway 101, the automobile replaced the train as a way to reach the coast. (Courtesy of Oregon State Archives, 320514.)

These beach lovers are enjoying a fun day in the sun at Cannon Beach. Photographs like this were used for promotional materials and brochures for the Oregon Department of Transportation. Although swimsuit styles may change, the love of the beach is always the same. All beaches in the state of Oregon are designated public recreation areas and are jointly managed by both the State of Oregon and the local municipalities. The foresight of the state in declaring beaches public recreation areas ensured that the beautiful beaches are free for everyone to enjoy and use, visitors and residents alike. (Courtesy of Oregon State Archives 602197.)

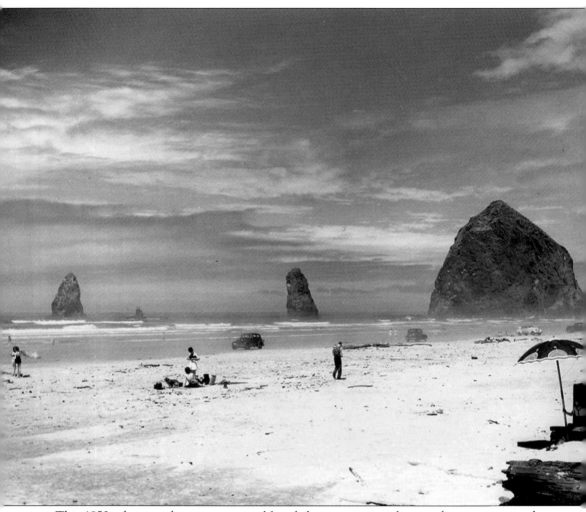

This 1950s photograph captures several beach lovers enjoying the coastline on a sunny day, whether lying in the sun getting a tan, taking pictures, playing in the cool ocean waves, or just searching for shells. The source of Gov. Oswald West's inspiration for protecting the tidelands and his love for Oregon's beaches can be traced directly to his lifelong summer retreats to Cannon Beach for his vacations. Later in life, with the entire Oregon coastline to choose from to build a home, he still chose beautiful Cannon Beach as the place to do it. (Courtesy of Oregon State Archives, 945596.)

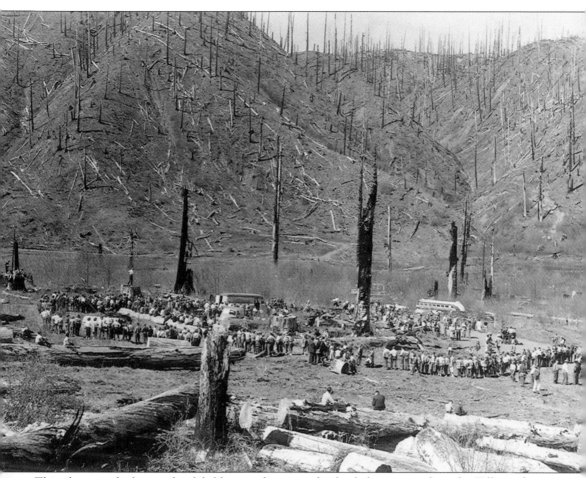

This photograph shows schoolchildren at the start of a day helping to replant the Tillamook Burn around the 1950s. The horrible and devastating Tillamook Burn was actually a series of four fires. The first, in 1933, was created by a steel cable rubbing against dry bark and burned 311,000 acres. Debris from the fire spread 500 miles out to sea, and loss of lumber was high. The second, in 1939, was started by a logging operation and burned 190,000 acres. The mysterious third fire in 1945 was joined two days later by another fire that was started by a discarded cigarette. This fire burned 180,000 acres. The fourth was in 1951 and burned 32,700 acres. (Courtesy of Oregon State Archives, 11990456.)

"The Evolution of the Bathing Suit 1850–1960" was featured in Sam Snyder's Water Follies at the 1951 Oregon State Fair. Some of these swimsuits are comical by today's standards, but in 1907, a woman named Annette Kellerman was arrested on a Boston beach because she showed up in a one-piece suit! In the 1920s, suits covered a person from the neck to the knees. The bikini was invented in 1946. (Courtesy of Oregon State Archives, 536615.)

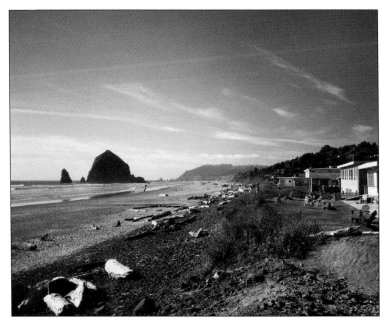

This postcard image was taken in July 1972 looking north from the front of the Major Motel and Apartments, now the Ocean Lodge at the corner of Pacific and West Chisana Streets. In the 1970s, the population of Cannon Beach almost doubled, growing from 495 to 779 residents. (Courtesy of Thomas Robinson, ackroyd C03290-1.)

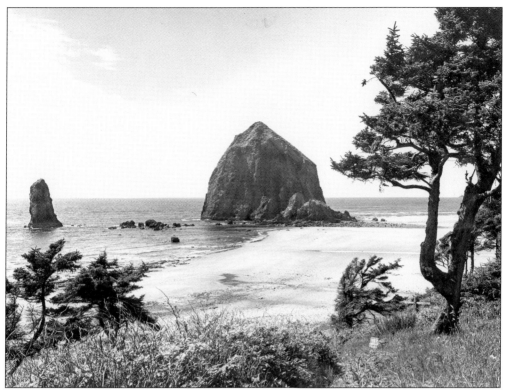

Haystack Rock is pictured around the 1960s, before the coastline was developed. In the 1960s, there were less than 500 residents in Cannon Beach. Tillamook Rock can be found on the line of the horizon to the right. In 1904, a developer by the name of Mulhallan filed a land claim on Haystack Rock. The size and location of the lots that he envisioned and the design of the homes he planned to construct there are unknown. Thankfully, the ridiculous claim was denied. (Courtesy of Oregon Department of Transportation, HaystackRock0001.)

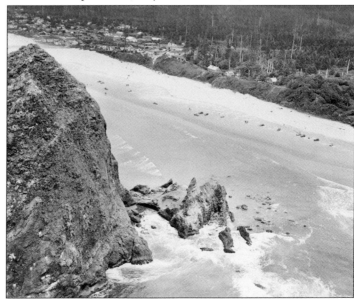

This bird's-eye view shows Cannon Beach from Haystack Rock in July 1947. The Oswald West house is on the right. At that time, a large portion of the town was still undeveloped. (Courtesy of Thomas Robinson, 9969-7029B.)

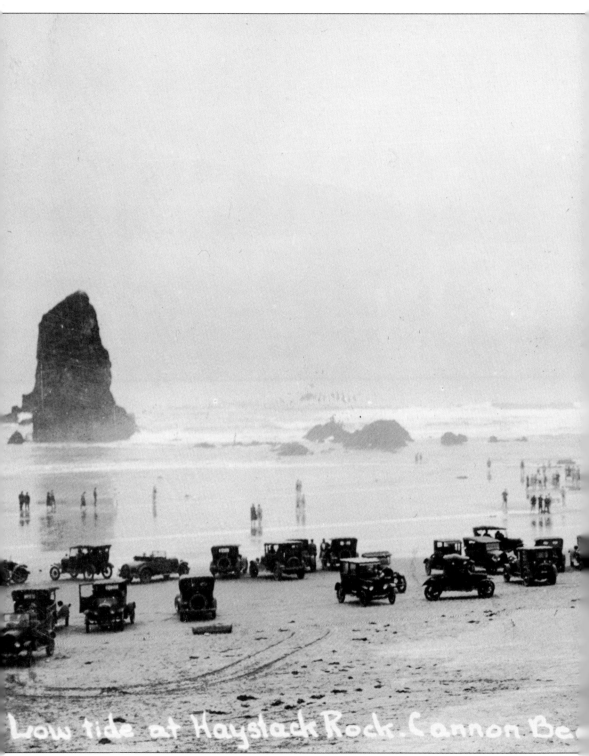

Low tide at Haystack Rock. Cannon Be[ach]

Low tide at Haystack Rock in the 1920s brought dozens of tourists and locals to comb the shoreline for shells. Their old Fords were driven right onto the beach. Haystack Rock was once joined to

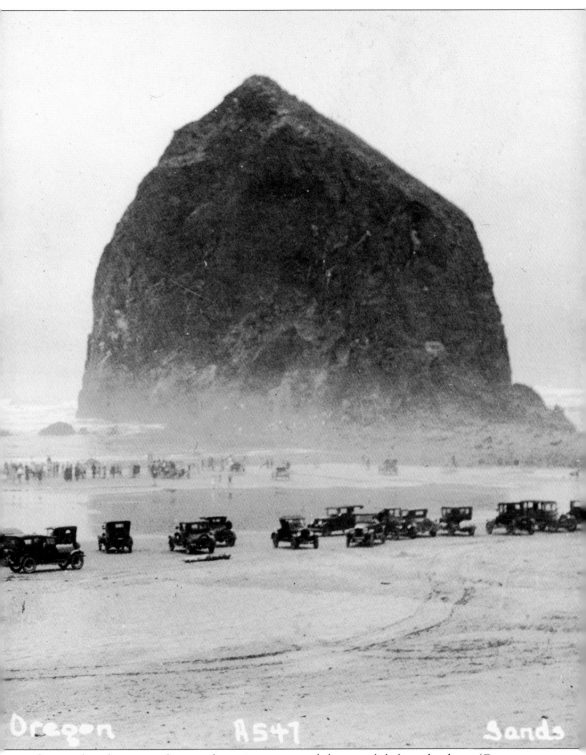

Oregon A547 Sands

the coastline, but years of erosion have since separated the monolith from the shore. (Courtesy of Norm Gholston and Thomas Robinson, OPS-29-11.)

This woman is holding a fine blanket made by the Oregon City Woolen Mills Company. The blanket pattern was called "Big City Lights" and was made from 1922 to 1931. This location is now the Tolovana Beach State Recreation Site. (Courtesy of Thomas Robinson Grabbler 1305-J2.)

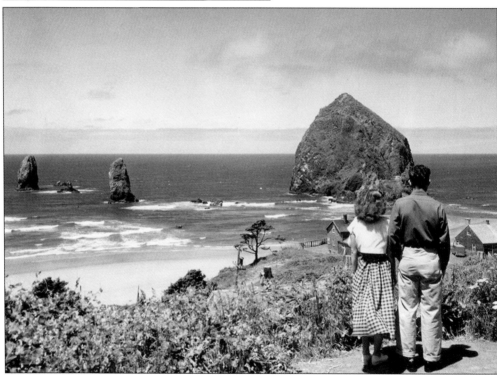

A couple looks out over the bluff at the timeless beauty of Haystack Rock. A couple of cottages can be seen below, and the Needles are off to the left. This photograph was probably taken in the 1950s. Haystack Rock was granted marine garden status by the Oregon Department of Fish and Wildlife in 1990. Collecting plants or animals from the tide pools near Haystack Rock or the Needles is strictly prohibited, and disturbing nesting birds is also not allowed. (Courtesy of Oregon Department of Transportation, 933932.)

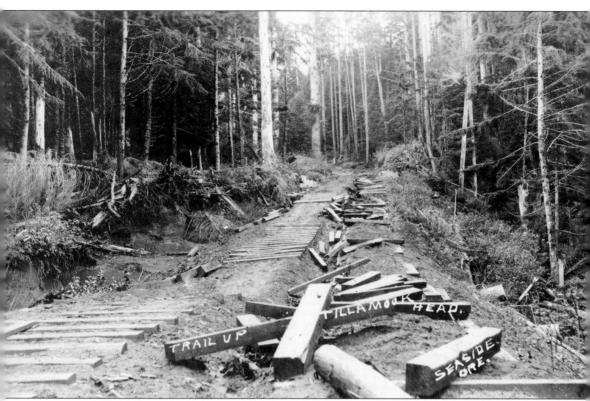

This unusual photograph shows a trail to Tillamook Head being planked with logs cut similar to railroad ties. The photograph reads, "Trail Up Tillamook Head. Seaside Ore." A lot of hard work went into creating the parks and the hiking trails. The park's network of trails today includes an eight-mile segment of the Oregon Coast Trail and a two-and-a-half-mile historical interpretive route called the Clatsop Loop Trail. Part of the Clatsop Loop Trail and the trail over Tillamook Head follow in the very famous footsteps of the Corps of Discovery team—Meriwether Lewis, William Clark, and the 12 members with them—as they traveled through what is now Ecola Park in 1806 in search of a beached whale near present-day Cannon Beach. (Courtesy of Norm Gholston and Thomas Robinson, OPS-29-47.)

Two lovely ladies pose on a large piece of driftwood on the coastline around the 1950s. Some classic automobiles can be seen parked in the distance. The summer of 1985 was the final summer that Cannon Beach allowed automobiles to be driven on the beach, although since the traffic is so heavy during festivals and parking is limited, the city now allows parking on the beach during designated times. The Annual Sandcastle Contest is one of them and is now the oldest known sandcastle contest in the Northwest. Going strong for over 50 years, the tradition is one of the biggest events of the year each June and can attract around 15,000 visitors. (Courtesy of Oregon State Archives, 1045084.)

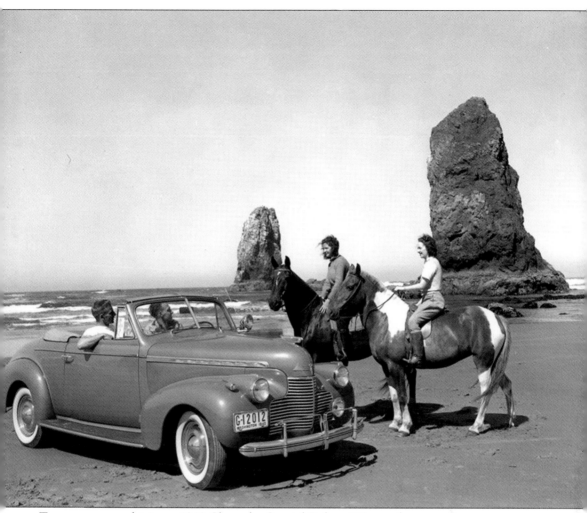

Two young men driving a 1940 Chevrolet Special Deluxe KA get close to two young women riding horses on a glorious day at Cannon Beach. Horses can still be ridden on the beach, and there are several businesses that specialize in it. Although cars cannot be driven on the beach anymore, there are plenty of places that rent bicycles, fun cycles, kayaks, and surfboards. (Courtesy of Oregon State Archives, 1231618.)

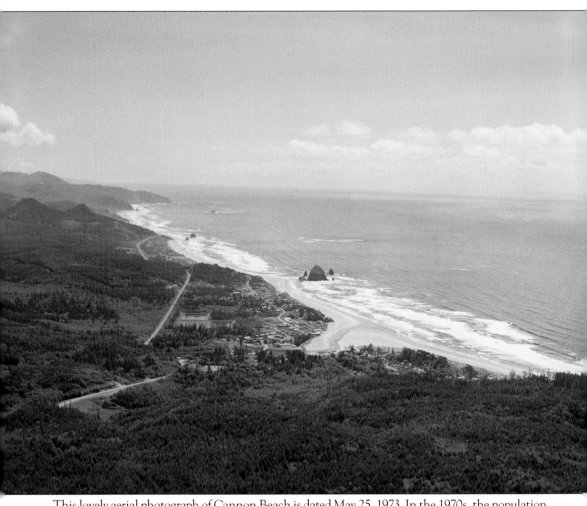

This lovely aerial photograph of Cannon Beach is dated May 25, 1973. In the 1970s, the population of Cannon Beach reached almost 800 residents. It is hard to imagine back to the time in 1892 when Logan and others platted the area from Elk Creek to Haystack Rock and offered plots that were 50 by 100 feet for just $100 each. (Courtesy of Thomas Robinson, ackroyd_18323-10.)

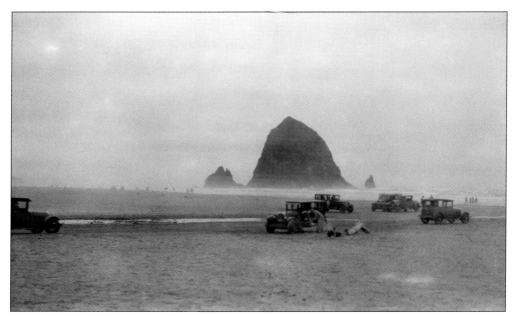

A group of motorists enjoy a day driving along the beautiful coastline near Haystack Rock in the early 1920s, although it appears maybe the person in the middle might be having some mechanical trouble. Even so, there can never be a bad day at the beach! The combination of low land prices, low lumber prices, and no permits or building codes to worry about meant that small cottages soon sprang up all over the coast. (Courtesy of Thomas Robinson, 8610-13.)

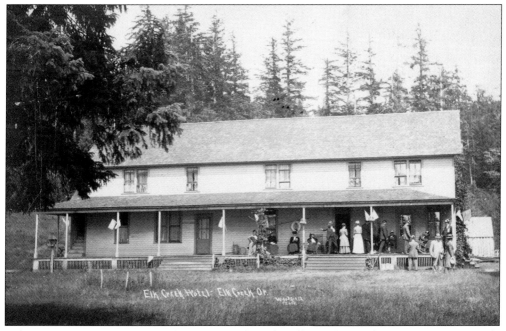

A large group of patrons enjoy the front porch of the Elk Creek Hotel. In 1892, Logan eagerly constructed and operated the hotel on his 158-acre homestead (now called Ecola Creek). (Courtesy of Norm Gholston and Thomas Robinson, OPS-29-62.)

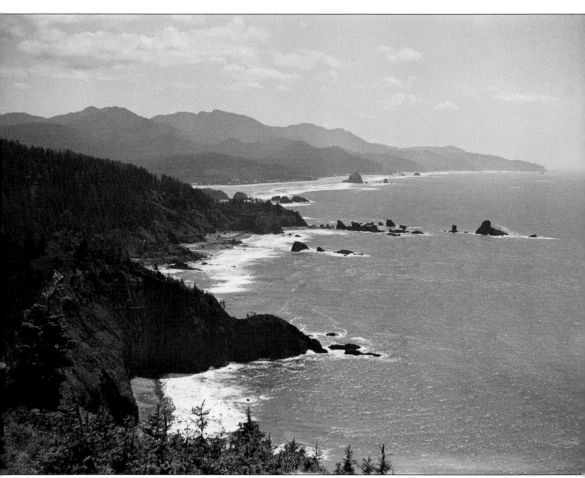

This wonderful view of Cannon Beach from Tillamook Head is dated May 20, 1934. Sections of Indian Beach and Crescent Beach can be seen as well. The trail runs up to Seaside and is the same one originally followed by Lewis and Clark in 1806. The primary purpose of the trip was to trade with the Clatsop Indians for blubber from a whale that had washed ashore. The Indians did not seem very interested in trading with the strange group, but they eventually did trade them 300 pounds of blubber. Clark guessed the beached whale was about 105 feet long. There is now also a horseshoe trail to Indian Beach and Indian Creek from Ecola Park for more stunning views, including an excellent view of Tillamook Rock Lighthouse. (Courtesy of Thomas Robinson, 9969-1456.)

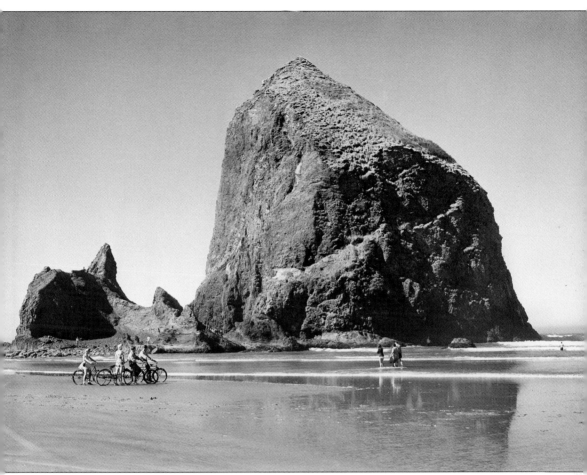

Another glorious day by Haystack Rock at Cannon Beach is seen on September 4, 1944, with four cyclists riding their bicycles along the shoreline. Three beachcombers are walking toward Haystack Rock, probably to enjoy looking at the tide pools. Haystack Rock rises 235 feet out of the sand and the sea at low tide. At low tide, starfish can be seen clinging to rocks in the tide pools. As a rule, no living organism that is attached to a surface should be removed. Marine life such as limpets, chitons, barnacles, mussels, sea stars, and urchins are attached directly to rocks (permanently or temporarily), and using force to remove them would be harmful to them. It is best just to take pictures and let them feel safe in their home. (Courtesy of Thomas Robinson, 9969-6024.)

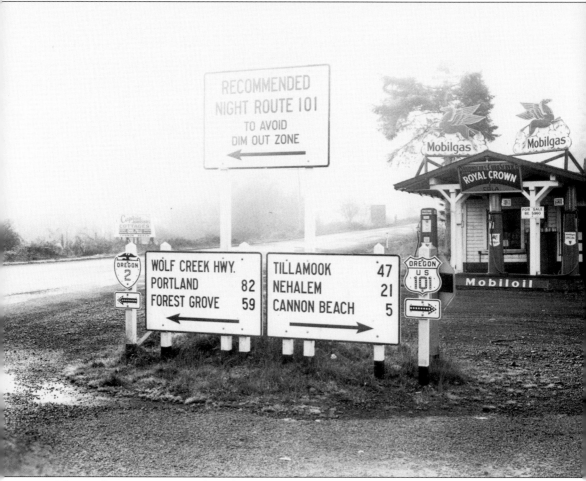

This road signage was posted on the way to Cannon Beach during World War II, when it was common to "dim out" or "black out" electric lights so that enemy planes could not see or target towns easily. These rules started in September 1939, before the declaration of war. All windows and doors had to be covered, and Lt. Gen. J.L. DeWitt required all communities along coastal cities to be able to black out their homes in less than 60 seconds. (Courtesy of Oregon Department of Transportation, Sign001.)

NOTICE TO ALL CITIZENS OF PORTLAND AND VICINITY

BLACKOUT

AND DEMONSTRATION OF UNITED STATES ARMY AIR INTERCEPTOR AND COMBAT FORCES

Friday, October 31, 1941, About 10 P. M.

Purpose: 1-Officially to test the Northwest air combat and interceptor forces of the United States Army.
2-Officially to test civilian defense units of Portland and vicinity.

INSTRUCTIONS TO THE PUBLIC
Complete Public Cooperation Is Urged in All Phases of This Defense Test.

1—Warning of impending blackout will be sounded upon the sighting of bombing planes by outpost observers. Exact time indefinite. About 10 P. M., Friday, October 31.

2—Air raid warning will be by means of sirens sounded throughout Portland.

3—At such warning you will immediately turn off all light visible from outside. **Do not pull main switches.** Cover windows where turning off light is impracticable.

4—Each resident is asked personally to see that no light is visible from his home or apartment.

5—Light no matches during blackout period of approximately 15 minutes.

6—If you have a skylight, make sure no light shows.

7—Keep tuned in to your radio for warnings and for running description of the test throughout the territory.

8—During blackout do not **cross streets.** Remain where you are.

9—Please obey promptly any instructions given by air raid wardens, firemen or policemen in your neighborhood.

Autoists—
At sound of warning, drive immediately to curb and stop and turn off lights. Do not attempt to operate car with lights off. Do not stop on bridges or street intersections nor at exits to buildings. Do not block fire plugs. Do not double park.

Outside of Portland—
Each individual owner is asked to turn off lights in home or factory.

Apartment Houses—
Management of all buildings will turn off all outside signs and lights.

Stores and Factories—
Be sure to have someone on duty to attend to lights.

Main Switches—
Do not pull your main switch in home, store or factory. To do so may blow main-line fuses.

Air Demonstration—
If you are outdoors to watch the airplanes, remain stationary. Do not cross streets and do not smoke.

All Clear—
Three blasts of sirens and signaling devices will indicate the end of the test. Street and all other lights then will be turned on.

SPECIAL NOTICE—If you must be away from home or apartment, do not leave any light visible from the outside.

NOTE—This combined test of defense is sanctioned by the military forces and is officially ordained by ordinance of the City Council with penalties for violation (Ordinance No. 76089).
It is the purpose of all concerned to make it a voluntary civic and patriotic undertaking and the public is urged to completely and fully cooperate with the Army and civilian forces on such basis.

(Signed) **EARL RILEY,** Mayor of Portland and Director of Civilian Defense in Portland Metropolitan Area.

Portland's wartime blackout poster includes such rules as "Light no matches for 15 minutes," "If outside during warning do not cross the street or smoke," and "Upon warning you are to immediately turn off all lights visible from the outside." It must have been a very nerve-wracking time for citizens along the coast, always in fear of attacks or raids coming from ships. The Coast Guard used mounted patrols to cover more area than they could on foot. Blimps were flown slowly over the ocean during this time because they could spot a submarine easier than a fast-moving airplane could. (Courtesy of Oregon State Archives, 10379791.)

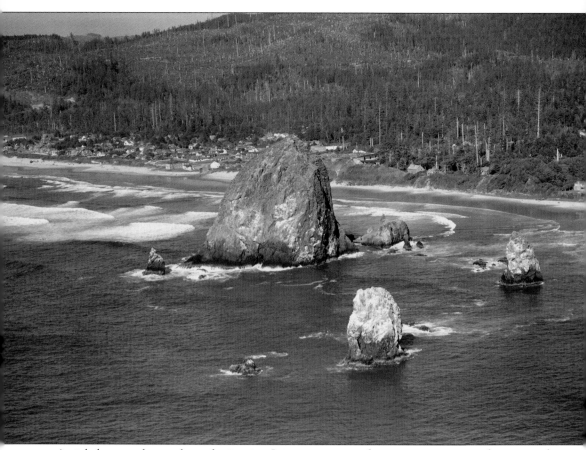

Aerial photographs are always fascinating. It is strange to see the waves moving away from instead of toward the camera. Haystack Rock, pictured here on September 13, 1949, is just as amazing as it is today. (Courtesy of Thomas Robinson, Ackroyd_01751-46.)

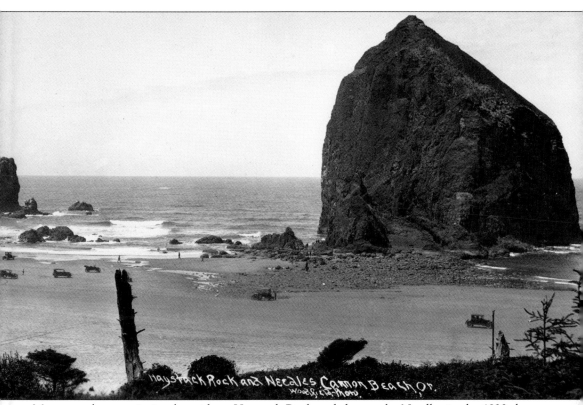

Haystack Rock and Needles Cannon Beach, Or.

Many people are enjoying low tide at Haystack Rock and the nearby Needles in the 1930s by beachcombing and investigating the tide pools. Even though it is tempting to remove marine life from Haystack Rock, if left alone it will remain a healthy environment for the animals that live there and will continue to be a precious ecosystem for future generations to enjoy. For millions of years, Haystack Rock has provided a home to many living creatures. This postcard is postmarked July 22, 1932. (Courtesy of Norm Gholston and Thomas Robinson, OPS-29-10.)

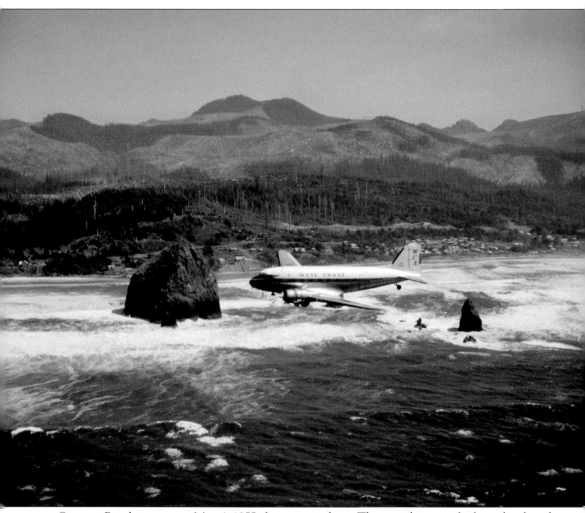

Cannon Beach is seen on May 4, 1955, from an airplane. The coastline was fairly undeveloped at this time, because the residential population was still less than 200 people. Haystack Rock has a small cave system that can be seen from the coastline. It is home to a large number of nesting birds, including puffins, cormorants, and lots of seagulls. To protect these birds, people are not allowed to go up on the rock itself. (Courtesy of Allen deLay, deLay 550504.)

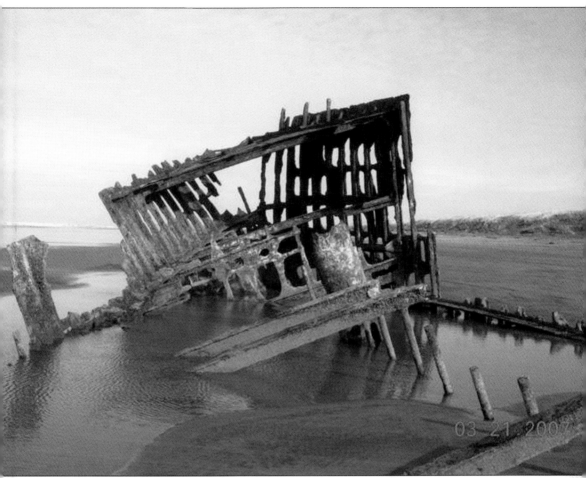

Captain Howison wasn't the only man who lost his vessel to the brutal graveyard in the Columbia River. The *Peter Iredale* was a four-masted steel barque that ran ashore October 25, 1906, on the Oregon coast en route to the frightening mouth of the Columbia River. Originally built in 1890 in Maryport, England, the *Peter Iredale* served for 16 years before the accident. Too large to move, the 1,993-ton shipwreck has been enjoyed by visitors for over 100 years. In 1960, a local man named Cliff Hendricks decided to warn the Oregon Highway Department that he owned the shipwreck, supposedly inheriting it from his father, who bought the wreck in 1908 for a mere $25, and was going to salvage the metal. Records showed that his father had actually sold the wreck for $325 a couple days later, leaving Cliff without a claim. (Courtesy of Oregon Parks and Recreation Department, Oregon State Archives.)

Three local women (Margaret Atherton, Billie Grant, and Marion Crowell) decided to try to lift the spirits of locals and tourists alike after tsunami damage (flooding and washing away the bridge) caused by an earthquake near Alaska in March 1964, so they began a sandcastle building contest to draw in tourists. Now the event is going on 50 years and is one of the most popular

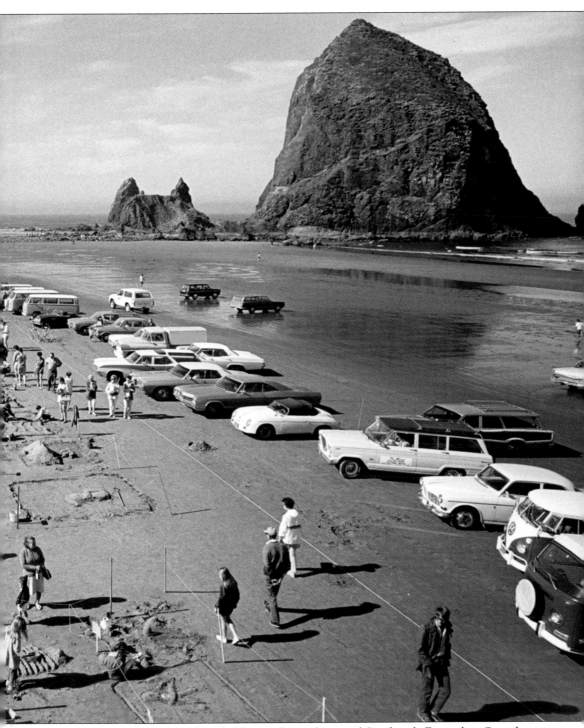

tourist attractions for Cannon Beach. Here is the sixth annual Sandcastle Festival on Saturday, July 18, 1970. Today, tens of thousands of visitors come to view the sandcastles before they are washed away, and the contest weekend is one of the busiest of the year for both the beach and Ecola State Park. (Courtesy of Thomas Robinson, falconer 162B-12.)

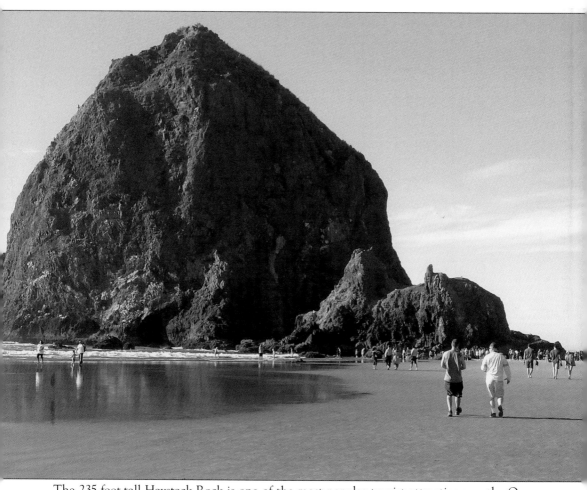

The 235-foot-tall Haystack Rock is one of the most popular tourist attractions on the Oregon coast. It has been photographed countless times by people from all over the world. It is estimated to weigh over a million pounds. Haystack Rock is complemented by two smaller rocks, the tall, elegant one being named Sven and the smaller one being named Lori. With its fascinating tide pools and local bird populations, people can enjoy bird watching and beachcombing year-round. (Author's collection.)

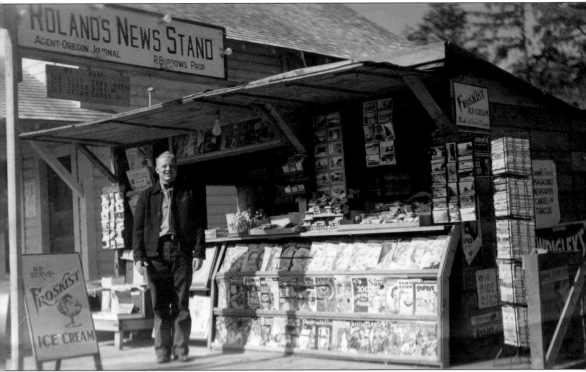

Roland's News Stand, owned by R. Burrows, is pictured in summer 1935. Over 50 different Cannon Beach real-photo postcards are visible in the racks spread across the counter. Magazines visible include the April 1935 issue of *True Confessions*, the August 1935 issue of *Modern Screen*, and the September 1935 issue of *Famous Detective Cases*. (Courtesy of Norm Gholston and Thomas Robinson, OPS-31-03.)

DISCOVER THOUSANDS OF LOCAL HISTORY BOOKS FEATURING MILLIONS OF VINTAGE IMAGES

Arcadia Publishing, the leading local history publisher in the United States, is committed to making history accessible and meaningful through publishing books that celebrate and preserve the heritage of America's people and places.

Find more books like this at
www.arcadiapublishing.com

Search for your hometown history, your old stomping grounds, and even your favorite sports team.